C000132971

THE MOON IS BEHIND US

STEIDL

THE MOON IS BEHIND US

30 letters in response to 30 moons

FAZAL SHEIKH
TERRY TEMPEST WILLIAMS

For our mothers

Never again will a single story be told as though it were the only one.

JOHN BERGER

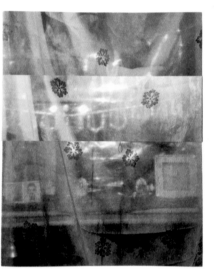 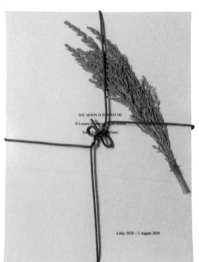

THE MOON IS BEHIND ME

30 Letters to the Moon

Te'lisha Louise Williams

4 July 2020 — 3 August 2020

THE MOON IS BEHIND US

Fazal Sheikh

In the summer of 2020, while in the grip of the pandemic, with lockdowns mandated across the world and violence against people of color escalating in the United States, a sense of the world being slowly upended took root in our souls. Confined to our homes, many of us shared personal exchanges throughout the days and nights across the miles of solitude. From Zurich, where my partner Alexandra and I were locked down, it was hard to imagine that only a few weeks earlier I had been planning to travel with my friend, the writer Terry Tempest Williams, to one of the largest oil and gas installations in the western United States, part of a project to examine the impact of industrial-scale mineral extraction on the American southwest and the effects of environmental racism on the Native communities with whom we were in partnership.

In 2017, a few months after Terry and I first met, I had visited her at her home in Castle Valley, Utah, where she lives with her husband, Brooke Williams. We were en route to Bluff, a town in the southern corner of the state, where she had arranged for us to meet with the elders of Utah Diné Bikéyah, the five-tribe coalition which had succeeded in winning approval for the protection of 1.35 million acres of land in southeastern Utah. The establishment of Bears Ears National Monument on December 28, 2016 had been one of the last acts of President Barack Obama. Less than a year later, as one of the first acts of his new administration, President Trump, through an executive

order, reduced Bears Ears by eighty-five percent and nearby Grand Staircase-Escalante National Monument by half, a move that would enable extensive tracts of public lands to be opened to uranium mining and oil and gas development.

As we surrendered ourselves to the new uncertainties, Terry and I explored new ways to continue our collaboration. We maintained an intense correspondence, checking in with one another to be sure that family and friends were okay, venting anger and disbelief at the news as it arrived each morning, and generally offering one another the comfort of solidarity and a shared perspective. We also questioned the role of art in such circumstances, asking each other how it might be used to offer empathy, inspiration, as well as solace to others.

Our friend Jonah Yellowman, spiritual leader of Utah Diné Bikéyah, fellow artist, and collaborator, had reflected upon the ravages the virus was wreaking upon his own community. This was a time to go deeper, he told us, to become more introspective about the way in which we lived our lives. And as the days passed, his words settled into my being and I took refuge in the process of making, selecting, and printing images from my last travels with Jonah. This in itself provided a focus and relief from the anxieties brought on by the world outside. I then set myself the task of preparing a personal gift for Terry. I decided to review the thirty years of my work as an artist and gather together thirty photographs, one from each year, each to represent a single day in a lunar cycle. I named it "Thirty Moons."

I would rise each morning, gradually lured from the confines of my studio by tentacles of memory, back to the moment of having made the image. It was an instinctive desire to draw lessons from the people who had welcomed me into their

communities in the years before. I have always felt that it was important to make work that reaches across the divisions of race, gender, religion, and national borders. If we are limited to speaking for our own racial or national group—in my case, one which is already fractured and multi-ethnic—then how do we help to foster a wider understanding of others? This was, I knew, a belief that Terry, in her work, shared: that it was possible to speak *with* another respectfully, and sensitively, rather than *for* another, and to communicate on a human level that transcends these differences. The month of gathering, comparing, and preparing the images offered an opportunity to consider anew, and more deeply, what this work has meant to me; how immersion in the act of making provides not merely its own form of solace, but a grounding for the soul.

While I was engrossed in the process of looking through the images, searching for those that might resonate with Terry, outside in the world protests against racial violence were taking center-stage across the United States, and in Europe thousands were joining in solidarity. Demonstrators were crossing historic lines of division that at one time demanded that people of color speak for themselves. Suddenly, a breakthrough was being made, one which may prove to be the most enduring impact of these months of unpredictability.

As I prepared the parcel for Terry, I had no expectation of anything in return. For me, the chance to have such a determined focus had been the most important thing, and to be able to offer a gift in honor of our collaboration.

Having dispatched it, we continued our correspondence, texting, speaking, and emailing on everything from the severity of the upheaval and roiling dissent in America, to news from

friends in the Navajo Nation and other Native communities struggling in disproportionate measure with the virus, to the growing shift toward fascism and xenophobia that was taking hold in the country of our birth. All these conversations were punctuated with updates about our loves, our families, with moments of great sadness and soaring raucous laughter to soothe the pain of loss.

Then, in early August, a parcel arrived in Zurich unannounced, having traveled from Utah to my door. Terry and I share a tradition of allowing a special package to rest for a time, as if preparing for the encounter with its contents. A couple of days later, I opened the parcel and found a sheaf of paper, tied with a sprig of sage, and a letter dated August 6 in Terry's distinctive handwriting:

My Dearest Fazal,

From my hands to yours.

From the Thunder Moon in July to the Sturgeon's Moon in August, I wrote you these letters not by hand, but by heart, in response to and inspired by each photograph in 30 Moons. They are personal. They are casual; more stream of consciousness than polished thoughts and some may be a ramble from the desert. I simply let the force of each image carry me. I have loved living, feeling, and thinking with you, Fazal, as I entered these portraits and portals of 30 Moons for 30 days.

It has been a beautiful and challenging practice as a writer and as your friend.

And to this she appended a quote from one of her favorite writers:

You will get letters, very reasoned and illuminated, from many people; I cannot write you that sort of letter now. I can only tell you that I am shaken, which may seem to you useless and silly, but which is really a greater tribute than pages of calm appreciation.
— Virginia Woolf

The manuscript was bound with a thin turquoise leather chord. As I sifted through the pages, I could see that each day opened with a re-photographed image—the original having been laid on one of Terry's patterned fabrics, as if to represent its new home. One image for each day of the moon's cycle.

That afternoon, I sat down with Alex and read each letter aloud, making my way through them in a sitting. By the end, it was clear that the insights Terry had given with such loving care to the images had brought the gift full circle; and this, despite the miles of our separation and weeks of imposed isolation.

In the following days, I returned often to the letters, enlivened by Terry's fresh perspective. As our exchanges continued, the idea grew in me that since they addressed so many aspects of the current situation, questioning the extremes of political, social, and racial divides, maybe these letters could be shared with a wider public. I proposed that we publish "Thirty Moons" in book form in the hope that it might reach others who were feeling equally undone and pulled away from life's moorings.

Terry was hesitant in the beginning about making the letters public. The letters were honest and unchecked expressions—in her words, "like a jazz riff." But then, we realized, we are all vulnerable. This is our shared offering born out of a vibrant friendship in the midst of a global pandemic—a modest and heart-felt project, made at a time of isolation, to soothe and comfort others, as we have comforted one another.

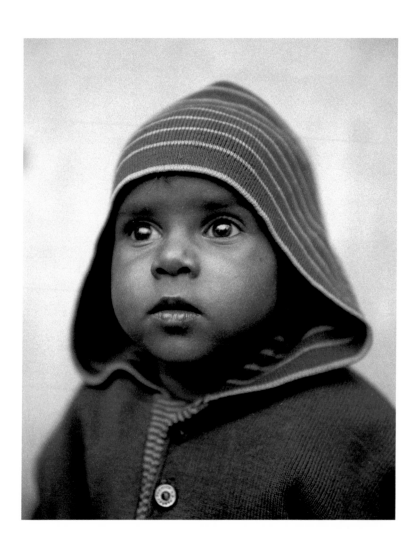

Dearest Fazal,

Thank you for the exquisite, unexpected gift of "30 Moons" that has traveled across the distances from Switzerland to America, from Zurich to Castle Valley, Utah. It took me several days to find the clarity of mind to open the mysterious slip-case made from a photograph: a shroud, a scrim, a veil. I held it in my hands like a family album, yours, not knowing what I would find inside. Through the gauze-clothed cover I detect framed pictures, snapshots placed on shelves with all manner of hidden objects. I see a bejeweled mask with eyes watching me like your eyes unblinking. The embroidered flowers on the delicate draped fabric create a deceptive foreground, a tease that the contents inside will be a soft unfolding. But I know better, having spent the last three years with you in collaboration, an artist and a writer, traveling and attempting to translate the arresting landscape of Bears Ears National Monument with the community of Native People who surround Bears Ears and live in this dry, erosional beauty.

I turn the slipcase over and find the seam exactly where these thin curtains open or close depending on one's intent—clues are now offered. I have no choice but to enter in—and as I do, I am met by a girl with her eyes wide open. She is looking past me, past you to a place of light that is shining through her. If the future is holding her gaze may it be gentle and kind, but given where we are now in a global pandemic in the throes of the climate crisis, I know this is magical thinking. Children

such as this beautiful brown girl wearing a carefully constructed sweater with a striped hood framing her face deserve a cloak of hope. One shiny silver button that keeps her sweater closed tells me she has a mother or father who cares as we had, dear Fazal.

Her mouth turns downward, her upper lip dark with a line of light shining on what is known as the angel's bow. Two small circles appear on her lower lip like drops of dew. Her nose is round, tending upward. A tiny tuft of black hair peeks out from the hood, but the focus of her eyes will not be deterred. There is a story here, an illuminated moment that you were there to witness.

Is this what childhood is—a series of moments when the world lights up and invites you in? Or is it the time when we learn how to look adults in the eye before they can hurt us, a reminder to us now that we, too, were once a child born into this world as an innocent?

Just now, a young Say's phoebe is perched on the back of the chair on the porch. Our eyes meet. It flies to the next chair closest to me, our eyes meet again, and it flies toward me fluttering in midair for a closer look and returns to the same chair. I continue to write as it stares. It has not yet learned to fear me or our kind. It flies again. The wee little bird is now hiding in the willows. Oh my—the phoebe is standing on my head as I write to you—I must be still.

The phoebe is hovering above me, she flies and is standing on the edge of the roof watching. I believe this child was looking at a bird. She is watching the bird now as her eyes look up from the photograph next to me.

Love,
Terry

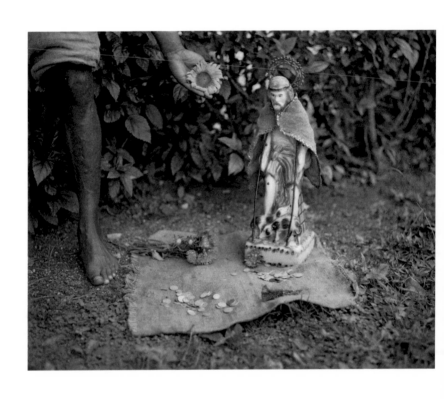

Dearest Fazal,

This morning felt like a hangover from the penumbral lunar eclipse casting its shadow on an already fraught Fourth of July. On the eve of Independence Day, a president called Trump stood at the podium, with Mount Rushmore as a backdrop, in front of a largely unmasked crowd of white supporters in the middle of a surge of Covid-19 cases. The throng's ecstatic response had been met earlier by roadblocks made up of the bodies of Sioux men and women saying this political party is trespassing on "stolen lands." They were arrested by a militarized police force and sent to jails with inflated bails that would hold them behind bars.

In a bold and dismissive act of disrespect to all Indigenous People, the 45th president of the United States stood on Lakota Sacred Lands, and said, "We are the country of Andrew Jackson…" He might as well have called Jackson by his nicknames "Indian Killer" and "Sharp Knife," this man who was the seventh president of the United States, who signed into law the Indian Removal Act of 1830—uprooting roughly 60,000 Native People from their home grounds and sending them on a "Trail of Tears," a death march for the Cherokee, Muscogee, Seminole, Chickasaw, and Choctaw Nations, the path that led to cultural genocide.

And a few lines later in his dark and divisive speech, Donald Trump eluded to "the evil protesters," debasing and mocking the uprisings surrounding the murder of George Floyd and the

Black Lives Matter demonstrations. He informed his audience that any radical who takes down a statue of American heroes will be hunted down and "sent to prison for a minimum of ten years." This "president" inflamed and ignited his own uncivil war of words by speaking in a code of cruelties.

It was revolting.

I stood outside in the eclipsed light of the moon and watched the shadows lengthen as the numinous light was reflected back on the desert as the face of the Full Moon returned. I could have read the *Declaration of Independence* by moonlight.

This morning I return to your second photograph: a small statue of a pilgrim saint adorned with a halo who is walking with what looks to be two hounds. The porcelain hand-painted figurine is suspended in motion atop a square pedestal maybe three by three inches square. The holy one is placed on an empty burlap sack where coins have been tossed and offerings made. A man whose face we cannot see leans in toward the saint and makes his own offering of a sunflower in hand. The man's body is also hidden save for his left leg revealing the crumpled fabric of shorts above the knee and his bare foot that is facing us. The side of his toes are only an inch away from the frayed cloth on the cleared ground. A hedge of veined leaves mirrors the veins on the man's leg—outstretched and attentive the shrubs bind both supplicant and saint together. You who stand close, are also a petitioner. Tell me, dear Fazal, as artists, who are we petitioning and what are we petitioning for?

As ever,
Terry

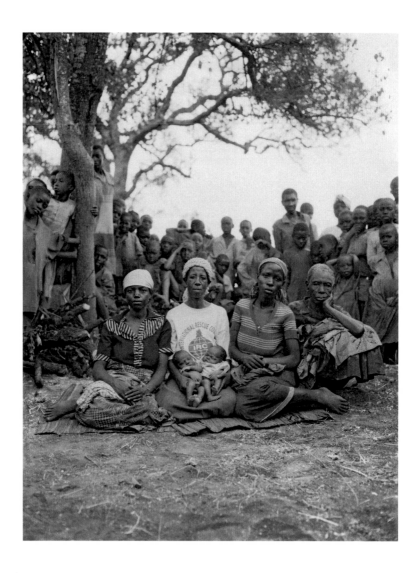

Dearest Fazal,

The temperature is rising. Castle Valley should reach 100 degrees Fahrenheit today. I am writing you from inside with Basho and Issa stretched out beside me. Brooke is writing in the other room. The blinds are closed, and it feels as though we are inhabiting a cave where colors are muted, and sounds are muffled.

We received the saddest of news, Jonah Yellowman's son, his namesake, died yesterday from the Covid-19 virus. I just got off the phone with Jonah. He said, "I have no words." The family is gathering at his place in Monument Valley. He is going to drive down to Phoenix to put things in order. He told me he talked to his son, Jonah, on Friday, who said he wasn't feeling well. Jonah told him to come home to Utah where the traditional medicines awaited him, that he could help him. He never heard from his son again. "He never let us know how sick he was," Jonah said. On Sunday, his older brother, also in Phoenix, went to check on him and he was dead.

Indian Country is being ravaged by the pandemic, Fazal. As you know, Jonah led a Navajo Nationwide "Ceremonial Call to Action" two weeks ago to ask the virus to leave and that their communities focus on the traditional medicine and ceremonial means that are theirs to heal themselves as they honor the power that they, the Diné, hold. We joined them in our own fire ceremony burning prickly pear, yucca leaves, piñon boughs, juniper, and sage as instructed. A thick and winding smoke animated by collective prayers rose upward as we smudged ourselves in silence.

Harvard announced today all classes through 2020–2021 will be taught online due to the surging coronavirus. And so, there is no going back to Cambridge for this next academic year, we will remain here in the desert for the duration. I don't even know what that means.

The photograph of yours in my hands today offers a clue: A tree is framing three women, two babies in the lap of the woman seated in the center, and a man whose posture appears as a single bookend with his head held up by his left hand anchored by an elbow resting between his knees that he is hugging toward his chest with his other hand as they all sit on a mat on the ground. I see a polygamist and his three wives. Behind them stands their progeny, dozens of children, young and older facing your camera, some smiling, some not.

This is a family tree rooted in place.

Taking a closer look at this family through my grand-mother's magnifying glass, I count thirty-seven children. Eleven of the children are looking elsewhere, over their shoulders, to the side, down at the ground. One child appears to be talking to another, one nearby listens. Each expression on each child tells a story—like the girl with her arm around the tree, her head leaning against its trunk who is focused on something out of the frame; or the boy whose elbow is perched on his knee like his father with his hand on his forehead sitting atop a woodpile; or the young woman standing to the side opposite of the tree, whose hand covers her mouth and yet her smile remains visible. This is not one portrait of a family, but a multitude of small portraits born from multiple wives.

I share these polygamous roots with those you have be-friended and photographed here in Kenya, where your own

roots lay through your father by way of your grandfather who was born in Northern India and migrated to Kenya before Partition in 1947 after which those lands would be called Pakistan.

The man who would bookend my great-great grandmother as a plural wife in Utah would be called Mr. Bunker. Or on Brooke's side of the family, "Brother Brigham" would suffice, a man with not three wives but fifty-five wives claimed as his. By the time of his death, Brigham Young, the great Mormon colonizer, would have fathered fifty-six children by sixteen of his wives with forty-six of his children reaching adulthood.

A friend of ours, Ken Sanders, who is an antiquarian book-seller, came across an archival photograph of Brigham Young seated next to "one of his wives" whose face had been scratched out. What wasn't removed was the turquoise and silver brace-let wrapped around her brown wrist accentuated by the sheen of her jewelry. She is believed to be Navajo. Ken approached the Church of Jesus Christ of Latter-Day Saints who bought the photograph immediately for their collection for a sizeable sum. It is no surprise this photograph has disappeared from their archive as the Church may not have wanted this known or discussed.

Brooke and I once gathered as progeny of Brigham Young in the Mormon Tabernacle where we witnessed over 10,000 cousins all seated beneath one historic roof on Temple Square. Each descendent wore a white square badge with a number to denote which wife they sprang from. Brooke's badge, as one of Brigham Young's many great, great grandsons, bore the #2: Lucy Ann Decker was Brigham's second wife, but his first plural wife. She was twenty years old and would become a mother

of seven children. Clarissa Young Spencer, her daughter, married John Daniel Spencer, father of Helen Spencer who married Rex Winder Williams, Sr., and was mother to Rex Winder Williams, Jr., Brooke's father.

My matrilineal line from polygamy goes like this: Emily Abbot Bunker, first wife of David Bunker, mother of Cynthia Celestial Bunker (who was the daughter of Emily and fathered by a freed slave working on the railroad in Ogden, Utah), mother of Vilate Lee Romney, mother of Lettie Romney Dixon (who was born in Colonia Dublán, Mexico, part of the Mormon community that fled Utah, where polygamy had been banned), mother of Diane Dixon Tempest, my mother.

My focus returns to the two babies resting in the lap of the wife in the center whose hands cradle their tiny legs. I want to kiss their little feet like I do with my own nieces and nephews.

Now I am looking more closely at the women and I am wondering if the fourth individual I thought was a man is actually a woman. It is her weary gaze that convinces me I was wrong. Maybe this photograph is not a polygamist family portrait at all, but four women and their children on the run.

I have just projected my own history on the history of these women who have been displaced from their homes and families, relocated to a camp and place unknown to them, as we white people so often do. I just made up a story not seeing who these women and children really are but who I imagined them to be. The woman in the center wears an oversized white t-shirt that reads "International Rescue Committee." The IRC logo of a globe appears beneath its name. "The IRC Aids Refugees & People Whose Lives Are Shattered By Conflict & Disaster" their website reads.

I am looking at a refugee camp. I am staring into the faces of mothers and children who have been displaced and traumatized by conflict or famine or war. Let me get out of the way so I can witness the strength and sorrow and resiliency reflected in the light and shadows of their faces who are facing you.

Not until this moment, did I remember to turn the photograph over and find your elegant script, now a compass point I will use to orient myself:

Nyirabahire Esteri, traditional midwife, holding newborns Nsabimana ("I beg something from God") and Mukanzabonimpa ("God will grant me, but I don't know when"), flanked by mothers Kanyange, Mukabatazi, and her mother, Rwandan refugee camp. Lumasi, Tanzania, 1994.

Survivors of the Rwandan genocide. Life in the midst of death. A midwife to life during war. Humbled, Fazal. Caught in my own version of colonial solipsism. All I could see was my own history projected on to theirs. I pause. I look again. I know nothing, my dear Fazal, of the lives of those you have photographed. I only know the journey they allow me to take into my own history of women and children and the family trees we lean against looking elsewhere.

May I share a story of women helping women? I think of our son Louis's mother, Annonciata Kagoyire, from Rwanda. She survived the Rwandan Revolution in 1959, also known as *Umuyaga Usenya* or "Wind of Destruction." Another "59-er" like her was Paul Kagame, who fled the country and went to America only to return years later as part of the Rwandan resistance to fight the war in 1994 and would later become president.

Louis's mum married a Congolese man who owned land in Masisi. Mama Lisa, as she was called, shared their fields with the local women who were Hutu. They worked together as women who were farmers and sold their crops in nearby towns like Goma. Mama Lisa was beloved and respected. The women she had helped were now helping her when the war broke out. They protected Mama Lisa and her seven from their husbands who were hunting them because they were Tutsis. The women hid them for weeks, moving them from place to place to place until they could no longer harbor them safely. And then the women told Mama Lisa she must flee or they would be killed. The men found out what the women had done. Mama Lisa gathered her children together and gave them each a name to remember and sent them in various directions to fend for themselves. Before she said goodbye to her three oldest children, she said a prayer to keep them safe, and asked God to return them to her. And then they scattered in the depth of night. The three older children, Lisa, Samuel, and Louis (fourteen, thirteen, and eleven years old at the time), followed their mother's instructions, each one carrying a different woman's name on their lips as they found their way to the right women in the right villages who anticipated them. Each child was delivered safely to its mother (this was within roughly a three-month period), who was waiting for their return inside the refugee camp in Goma on the border of Rwanda and the Democratic Republic of the Congo. What happened within those harrowing months is their story to tell, not mine.

Now, when I return to the faces of these women with Nyirabahire Esteri seated in the center of this gathering and flanked by women who have just given birth, I say their

names: Kanyange on her left and Mukabatazi on her right, Mukabatazi's mother seated next to her—the woman I took to be a man who triggered my own story of the oppression of women. I see their strength, I see their resilience, and the ghosts that will walk with them forever.

I now see a gathering of the future and the postures of the children who will carry the burden of generational trauma.

Deep bows,
Terry

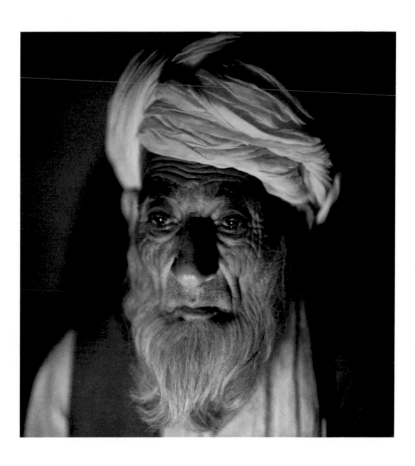

Dearest Fazal,

This man. A landscape. His face lined from life. In shadow and light, his eyes illuminated. I imagine him sitting by a fire, in a trance, as flames flicker and fade into the night. He appears to be looking outward, but his gaze is inward—past or future— where is he? What memories have been ignited, what worries have become inflamed? Or is he simply watching fire, unaware of yours that is making this picture. And always, my friend, I wonder where you are situated. How do you make yourself known and unknown, at once?

This man. A landscape. My father at home retreating further and further into the despair. "If I have only two more years to live and it is inside this pandemic, what is the point?"

This man. A landscape. In Pakistan, Afghanistan? Does he feel this way, too? What has he seen, what does he carry, hidden, untold? Do we ever really know another? And here is something I wonder about, does everyone on earth hold a secret?

I was once told a story that took place in the Maasai Mara of Kenya, a landscape as you know contiguous with the Serengeti. The storyteller was a woman of immense powers whose face held lines eroded by grief. This is what I remember: we were walking in the savannah, a sea of waving grasses as if they were being spun into gold by the wind.

"You see these grasses?" she said. "Their roots hold a great burden in place that is noted by ground-dwelling insects, the

retention of snakes and the trustworthy nature of burrowing creatures." We stopped.

I scanned the grasses all the way to the horizon. "Nothing is ever as it appears," she said. "Since the beginning of time, people come to the grasslands that stretch across all continents of the world to shed their secrets. They come to sing their solitary woes to the grasses who will listen in the heat of high noon. The humans kneel, hidden in the height of the grasses, as their hands start to dig a depression, a hollow, their hole to confess what is too heavy to carry any more. They bring their mouths down to the dirt and speak their shame to the grass roots as though they are whispering their allegiance to their lovers or those they have murdered or to the moment they lost themselves to anger, envy, or avarice. Some water their secrets with tears, while others bury them with remorse or relief or exhaustion. They cover their deep and dark confessions with a light patting of soil and the grasses once removed are returned to reclaim their upright stature—" the storyteller said as we continued to walk on a well-worn path tamped down by elephants and giraffes.

"But here is what people forget," she said, as she faced the tall animated grasses and extended her hands to them. "The grasses remember each secret given to them as a reversal of guilt and because we all know a secret cannot ever be kept alone, each blade of grass takes the whispers they have received and offers them up as a song or a prayer to each wandering breeze that touches them and in a split second of sweet agreement, the breezes carry them to a far-off place where darkness is married to the moon and gives birth each day to the sun." She takes my hand and looks ahead, "and that is why whenever

the wind blows through the grasses in the savanna, we hear the songs and prayers of the forgiven."

This man. This landscape. This light held in the darkness of his eyes has a story to tell.

All my love,
Terry

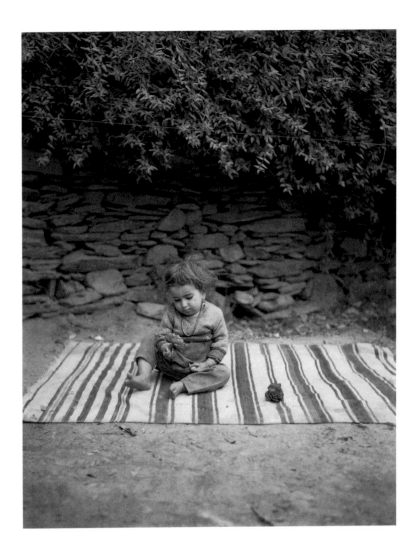

Dearest Fazal,

Why I feel compelled to open this letter to you with a peculiar observation, I cannot say, but in many of these photographs there is a rug or mat or blanket set on the ground for a person to sit. In this image, the rug is striped, woven with wool or cotton. Here in the desert, we sit on the sand, usually in shade. I want to adopt this practice. Maybe it's because I feel the need to have a buffer between the world and me at this moment in time. Little feels safe. Or maybe it's the severity of scorching heat saturating midsummer days that begs for cover of any kind, not just the covering of one's body, but the covering of the land. I know just the rug I will take down to the river, woven by my friend Teresa Cavasos Cohn from Montana. Wool shorn and spun from local sheep, the rug she gave us as a gift is also striped, but in colors of gray and maroon.

I imagine myself falling asleep on the soft rug holding down the loose sand beneath a cottonwood tree. Deep dry relentless heat sustains dreamtime in the desert. A siesta is more than a nap snatched midday to escape the sun. Siestas allow us to escape from a melting mind. I wear heat like a heavy cloak unable to move. Only the smell of sage snaps me back to an enlivened state of being—until the silky evenings that come awaken me like a lover.

The gesture of raising one's foot as a punctuation to a query is familiar and makes me smile as I see the little girl's foot lifted ever so slightly as she contemplates the rose in her hand, while

holding petals in the other. The companion rose that sits next to her is lovely. Did you place it there? Or was it an amusement left by her mother? That is something I would do. I remember when my nieces would come spend the night with us, I would draw them a warm bath before bed and sprinkle the water with rose petals. My grandmother did this for me, her quiet gesture to honor the beauty of women's bodies and the sensual pleasures we seek in solitude. I was young when this ritual began, perhaps the age of this girl sitting on the rug.

Grandmothers, mothers, daughters, women—we live and dream in circles. By this I mean, we have minds that twirl and arms that spin as we dance together, turning in the seasons of our births. The Moon conducts our moods and cycles, pulling and releasing the inner, outer tides within our bodies as we come to know we are water, we are fire, we are blood. Always, Earth.

Circles surround this pensive child beginning with the small solid dot in between her sweep of eyebrows appearing like an owl in flight. There are the circles decorating her pants to the circles of beads that adorn her neck and wrist to the unfolding circle of petals she holds in her hand that bears the fragrance of all that is fragile and strong. On the back of this photograph you wrote down an Afghan proverb: *A rose can come from a thorn, a thorn can come from a rose*—I would argue this is what every girl learns and what every woman knows. It is hard not to see the free wisps of this child's hair as a protest against the stonewall already crumbling behind her. Above her, leaves; below her, sand; the rug becomes a flying carpet steady enough to hold a rose in place.

With love,
Terry

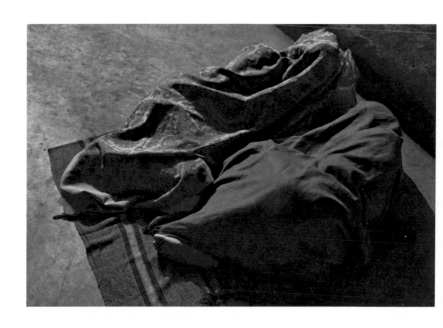

Dearest Fazal,

Good morning. Yesterday, Utah recorded its highest number of new Covid-19 cases: 722 with the death count rising. It is no consolation to find out we are just behind Brazil as one of the "hotspots" around the world, especially given Brazil, Russia, and America are currently banned from traveling to Europe. Canada and Mexico have also closed their borders to us. America is a contagion, with our feckless and tyrannical president continuing to spew massive droplets of hateful rhetoric into the global atmosphere.

Today: 3,067,780 confirmed cases in the United States and rising. Our death count is 132,979. Some epidemiologists say it will reach 200,000 before the election. We made a religion out of the tragedy of September 11 with 2,977 deaths. What are we making of this? These deaths from the pandemic remain an abstraction to most. But not to Jonah. Not to his family. Not to every individual in this country who has lost a beloved from the coronavirus, who most likely died alone or in the company of nurses.

The picture before me is tinted, tainted like Death.

On the back of this photograph you write, *Night-walking in Benares, India, 2012*. Another blanket on the ground, only this time it is not reserved for the living but the dead. One day this will be us.

Death will come.

Again, the haunting of this idea that plagued me throughout writing *Refuge*, "If I can learn to love death, then I can begin to

find refuge in change." This sentence never leaves me—It is my mantra spoken daily by the Raven who sits on my shoulder:

Deep into that darkness peering, long I stood there wondering, fearing, Doubting, dreaming dreams no mortals ever dared to dream before...

The Raven flies. He always returns. My sanity comes and goes.

Someone cared enough to cover one of the bodies in a paisley piece of cloth. The companion corpse with a bare foot exposed is draped and bundled in black. They are not sleeping, that is always my hope with the dead, that they are slumbering and will open their eyes if I stare at them long enough. This is the kind of hope I deplore, loathe, and find so cowardly because its roots are locked in denial—the kind of hope I never trust but want to believe. The quiet contemplative rapture that says Yes. No—these covered bodies are dead, left momentarily on a wool blanket of one stripe on the streets of Benares—to be burned.

I have some questions. Did you feel discomfort in photographing them, Fazal? Did you think twice or three times or four? Did I feel discomfort in writing about my mother, my grandmother, my two brothers' heartbreaking deaths? Or is all our artmaking, no matter the focus, the artist's mirroring of the self—our fears, our projections, our hypnotic walk toward beauty to transform our anger into sacred rage—as a way to survive our grief?

Or does Rainer Maria Rilke speak the unspeakable in the *Duino Elegies*: "For beauty is nothing but the beginning of terror, which we still are just able to endure, and we are so awed because it serenely disdains to annihilate us. Every angel is terrifying"?

Quoting Poe. Quoting Rilke. There must be a trilogy of wisdom here to distract me from touching pen to bone, delving too deeply in what is visiting America and the world in 2020: Death. Angels of Death are now attending to those who doubt their existence.

Let me consult Virginia Woolf: "Killing the angel in the house was part of the occupation of a woman writer." This I understand. Give me a shadowed life over a life of blinding sunlight and innocence.

A writer, if she is to tell the truth, cannot stand on the pedestal of decorum and discretion made for her by the men who would choose to tame her. Loyalty to angels has no place in a woman's study. The first line from our pen betrays their goodness. The day I killed the angel in *my* house was the day I wrote a letter to my grandmother's father, Park Romney, a true Mormon patriarch. I said, in a handwritten script difficult to read, "I will not obey—as my mother has done, as my grandmother has done, and as my great grandmother has—It will kill me if I do, just as it killed them."

These bodies in Benares, Fazal, are they the women who died by being good?

And so, my friend, it becomes imperative we transgress.

How do we transgress toward Death?

We live. We create. We endure.

But upon a deeper glance, with my grandmother's looking glass in hand, what if these figures are not dead at all, but sleeping? What if your *Night-walking in Benares* is actually you, enveloped in the cloak of night, on your quiet wanderings through the streets, creating through the alchemy of your lens an astute rendering of the dreamtime? What if these bodies

in repose wrapped tightly in cloth are not corpses at all, but sleepers—Call them the dreamers, the travelers, the pilgrims on their way to death waiting to attain *Moksha*, "across the waters of sorrow to the furthest shore from darkness"? I can hear your voice reciting this line to me in the ether. The line between sleep and death is thinly drawn with a breath.

What if, after you read this letter, you write me back, telling me these are your ancestors and mine, Muslims and Christians, who slept side by side through the generations and dreamed their lives into being and met their deaths with dignity and, in some instances, choice, as we will? You know them by name; you recite their names as a liturgy—your father's lineage, your mother's lineage—I would put your letter down and call you, too impatient to write, and I would say, "I'll believe you."

I am writing you now, Fazal, one last line for today, to let you know, I never take you for granted or fail to appreciate our unruly friendship that continues to surprise and soothe and stir my heart.

With love,
Terry

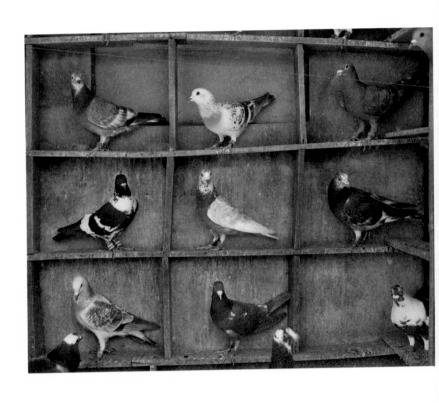

Dearest Fazal,

John le Carré tells the story of accompanying his father on one of his "gambling sprees" to Monte Carlo. He was a teenager at the time. Very near the casino was a sporting club, "and at its base" he tells us "lay a stretch of lawn and a shooting range looking out to sea." He goes on to write, "Under the lawn ran small, parallel tunnels that emerged in a row at the sea's edge. Into them were inserted live pigeons that had been hatched and trapped on the casino roof. Their job was to flutter their way along the pitch-dark tunnel until they emerged in the Mediterranean sky as targets for well-lunched sporting gentlemen who were standing or lying in wait with their shotguns. Pigeons who were missed or merely winged then did what pigeons do. They returned to the place of their birth on the casino roof, where the same traps awaited them."

I have been haunted by this story ever since I read his memoir, *The Pigeon Tunnel*, written in 2016. When I look at your photograph, *Rooftop pigeon roost, Delhi, India, 2005,* I can't help but wonder if this same kind of practice happens there as well.

Dovecote. Columbary. Coop. I see this photograph as a rendering of randomness and fate. When flying through the narrow confines of the tunnels, winging their way toward light, which pigeons will be shot and which ones will be spared only to fly back up to the roof and await another round of gunshots at dawn? And if we see the clear metaphor to our own species'

survival, at what point does an individual say, I will no longer place myself in the sights of a repeating round of abuse?

Stool pigeon. In the crosshairs. Framed. Nine pigeons are framed twice. Once—as eight birds standing sideways in individual wooden cubicles, three down and three across resembling a tic-tac-toe board with one rogue pigeon perched in a corner looking directly at the camera; and again, when the birds are framed in the white mat you made for this picture. Five other pigeons are glimpsed as fragments of feet and heads.

Seven of the nine pigeons are standing in the same direction, only one is facing the opposite direction, and the same rogue pigeon who is not quite in the ninth cubicle is facing the viewer directly. What is the posture of escape?

Here in the desert, wild pigeons or rock doves (*Columba livia*), descended from those in Eurasia, nest and roost in the creases of sandstone cliffs within the Colorado Plateau. We have many here in Castle Valley and I love listening to them coo at dawn and dusk, creating a comforting melancholia in the valley in sync with scorching summer days. Their iridescent feathers in flight register as hallucinations. When settled on the rocks they shimmer like heat waves. I have watched the swift grace of rock doves against an open sky fall prey and plummet at breakneck speed to the precision of a peregrine falcon strike on the hunt—a warning we are always being watched.

In the great cities of the world, pigeons congregate in parks and the gray-stoned plazas and piazzas of Europe. Some visitors come daily to pay homage to the pigeons with breadcrumbs, children wave their arms in delight to see them rise and mob the sun, and when they circle the churches and land once again, cranky locals make a habit to shush and shoo them away.

Pigeons are loyal, highly intelligent, and mate for life. They have fierce and sophisticated homing instincts, even at their own peril. These are facts. But when I watch the rock doves animate the desert, I see something very different, unnamable, unknowable, uncommon.

"To the creative writer," John le Carré writes, "fact is raw material, not his taskmaster but his instrument, and his job is to make it sing. Real truth lies, if anywhere, not in facts but in nuance."

There are no pigeon tunnels in Castle Valley, but the Sixth Extinction is its own dark corridor that lured the passenger pigeons (*Ectopistes migratorius*), the only pigeons endemic to North America, to oblivion in 1914 by similarly "well-lunched" men who had these multitudes in their crosshairs and fired indiscriminately never believing one day this many, this wild, could be this few, and then, gone.

Tonight, I will walk to the stone cliffs and wait—until I hear the rock doves singing through the silences of all those who have been murdered, both human and wild, as innocents unable to defend themselves.

As ever, my love to you and Alex,
Terry

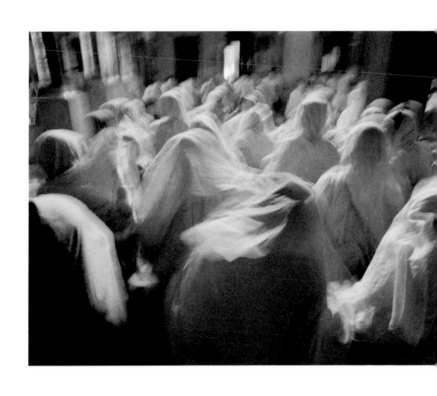

Dearest Fazal,

We are not so different, humans and birds; pigeons and people.
When I see this flock of believers in the Bhajan Ashram in
Vrindravan, India, I see migratory wings of devotion, the in-
stinctive pull to return and gather among one's own kind. But
then, because I know you, Fazal, I must seek facts and nuances.
What I thought were wings are now partial shrouds spun from
the filaments of the dead. What I discover is that these pil-
grims are women, their exodus from home is not of their own
choosing. Their husbands have died. Banished by their families
for the shame of being a widow they leave their communities
wearing garments of grief with little or no possessions save
their breaking hearts.

 Sometimes I don't want to know the story, Fazal.

 Sometimes I just want to make up my own story, create
my own narrative like I do when I'm reading a newspaper in a
foreign country in an unknown language. I don't have to face the
pain of the world, in particular, the pain of women. When the
hurt becomes intolerable, we can resort to speaking in tongues.

 But you didn't just give me thirty photographs—you have
placed in my hands across a great distance during a global pan-
demic a photographic map of your travels around the world.
I discovered if I turn over the image and read your delicate script
on the back of the photograph written with a thin black pen, then
you make me accountable. And because of our collaborations,
I understand what captions mean to you: context, story, injustices.

What I saw as birds, I see as grieving women mourning the lives and losses of their husbands together. Each woman cast out as a widow has found her humble way through an arduous path to the holy city of Krishna. Belief in the god she loves is replacing the body of the man she loved. Can a woman ever forget the man and the children that came through them? Can devotion of any kind, religious or secular, cancel a life lived before a new-found fidelity? Even a fidelity toward the self?

And I wonder how poverty directs and informs the lives of these widows who are now alone in the world at the mercy of the begging bowls they hold in their worn and wan hands. Their prayers and songs uttered on the streets are rewarded with scant offerings of food and coins. And where does a single woman go upon receiving the news that the ashram cannot accommodate her?

Perhaps this is the road to sainthood. Perhaps this is the path to insanity. Maybe there is no difference—despair marries devotion in order to survive, what every mother knows in the daily dissolution of her life given away to those she loves.

Widow is an ugly word.

You made this single word a plural beauty.

Love,
Terry

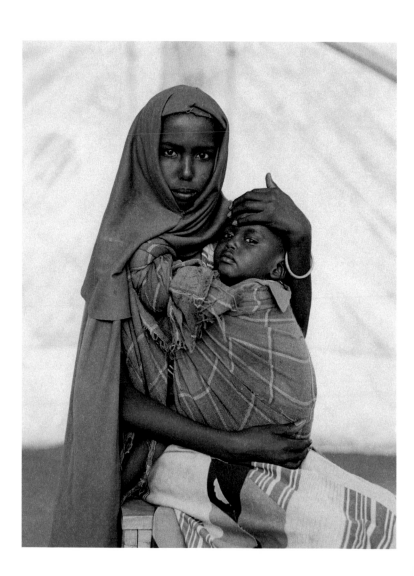

Dearest Fazal,

Children holding children.
Do we ever stop taking care of one another?

The dates of these portraits are 1993 and 1994. Two girls mothering their siblings, one pair from Somalia, in a refugee camp in Kenya; the other pair from Rwanda, in a refugee camp in Tanzania. Survivors of a famine and a war. And you were there, Fazal. I knew you traveled to Rwanda, but I didn't realize you were there as the genocide was flaring. I came later, a decade and a year later.

These sisters tending to their brothers: Alima Hassan Abdullai is keeping Mahmoud close, her right arm secures him on her lap, her left hand holds his forehead tight. He leans into her with his head pulled back as his eyes focus on you. Her gaze is direct. Wezemana is sitting on a wooden folding chair, weary, as her brother Mitonze sleeps, his cheek rests on her back as his little legs wrap around her waist. He is bundled in a cloth tied tightly in front just below her shoulders. She looks up, her eyes are shining. I wonder if those are stubborn tears.

I cannot look into the eyes of these daughters, sisters, and not see the likes of them holding our son who was also in a refugee camp in the Congo in 1994, as I mentioned to you in an earlier letter, trying to find his way back into Rwanda to his mother and grandmother. This is a recurring horror. Wezemana and Louis are close in age and both bear the same intentional scar on their forehead, a cut made to release the fever from malaria. Call them siblings in sickness and war.

I held my brother Hank here in the desert for close to two months after he almost died from the coronavirus in March. By held, I mean we were inseparable in those days of his healing, walking together, eating together, and sharing the silences when words were few. He was among the vulnerable ones, having lost half of his lung to "desert fever" when he was working pipeline construction in Phoenix, Arizona. In the fall of 2015, he spent 32 days in the hospital, and I spent those days and nights by his side. By his side, I mean I never left him until he could walk out of the hospital on his own. We learned our DNA is an exact match in 2004, when as siblings my brothers Hank and Dan and I prayed at least one of us could be a donor to our brother Steve for his stem cell transplant, a last effort to save his life from lymphoma—but none of our stem cells match except Hank's and mine.

"Hold on to each other," the doctor said. We held Steve with our hope. It was not enough. He died in 2005.

I reluctantly went to Rwanda seven months later at the invitation of the artist Lily Yeh to help build with a local community of Rwandan women a genocide memorial. I originally told her, no, I was afraid of Rwanda's history of so much death and sorrow. But I knew if I didn't go, I would regret it. Louis Gakumba was our translator. He became family. Living in Utah, he and my brother Dan became close. Louis and I were together when I learned of Dan's death by suicide in 2018. We were driving to Wyoming. After Brooke called to tell us the news, we found a meadow, got out of the car and sat down on solid ground. Louis held me as I could not hold my brother.

Time. Time together. Time apart. Zadie Smith says, "Time is how you spend your love."

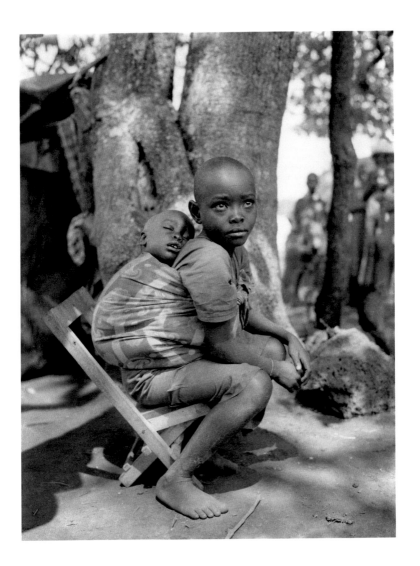

You and I just got off the phone a few hours ago after learning our friend-brother Jonah Yellowman lost his blood brother to Covid-19 last night, knowing one week ago, Jonah lost his son, his firstborn the one who carried his name, from the virus. I wrote to Jonah and sent a photograph of a lit candle burning on his behalf. You called him and through the distances shared his pain. To both of us he said, "It's not fair." And it isn't. I thought of your photograph of the winged widows gathered in the Bhajan Ashram offering their songs and prayers to Krishna. I believe in the collective power of sharing our grief and the healing that comes when we help carry that blow and burden for each other be it through prayers or songs or presence.

A sorrow shared is a sorrow endured.

Another friend-sister, Alexandra Fuller, a writer from Zambia, wrote this to me this morning, after the second anniversary of her son's death: "...The intensity doesn't change. A deeper, quieter, less forgiving, more lively grief replaces the screaming white-hot sparkling pain, the swampy filthy impossible depths. This grief is beyond words, like all miracles. If I get going toward the old, terrible, material loss, I can't imagine surviving. It's all about giving it to God. God has it all anyway, so holding on is useless..."

And she sent this poem she had written the night before:

God knows, you need God to get through the
death of your son.
Mary knew.

I have therefore reclaimed that loving,
compassionate space from the weaponized
old bastard of my youth.

My God is not up for grabs.
God is me.
God is also Fi, and of course, Mary, and
every bee, beetle, princess, frog, and atom.
God is infinite.

All the rowdy beauty, all the love, all the pain,
all the intolerance, all the irritation, all the
irrationality and all the anger: God is all of it.
God is the towering madness of grief.
That's a mind-dissolving thought.

When I was in Rwanda, the refrain I heard repeatedly was "*Mana y'u Rwanda wagiye he?*" Where has the God of Rwanda gone? In this, poignantly one hears the echo of the famous Rwandan proverb, "God spends the day elsewhere, but He sleeps in Rwanda."

Was he asleep during the genocide? Or was he weeping when it rained on the 800,000 bodies left rotting and buried in those thousand beautiful hills—feeling as helpless as we do today over the deaths that have laid at Jonah's feet.

My god has feet of clay, dear Fazal. I don't believe in him. I believe in these girls who are holding their brothers in times of hunger and terror; I believe in our mothers and grandmothers who held us at birth; and I believe in Earth who accepts each body as a blessed offering to life and death and love.

Always,
Terry

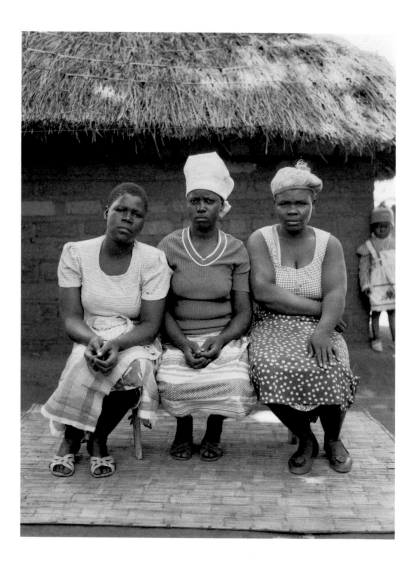

Dearest Fazal,

Good morning. The Tempest Clan has a new family member! June Birdie Kimball was born yesterday afternoon to Sara Teewinot Tempest and Scott Miller Kimball. She weighs 7 pounds 8 ounces. Her brother and sister Owen and Lettie are thrilled. Her great grandfather John Henry Tempest, III is elated. "There are now six boys and two girls to carry on the family name in this fourth generation," he said to me on the phone. I am sorry my brother Steve is not here to know these adorable children.

As Brooke and I went outside to say prayers of gratitude, a pink aura appeared above Adobe Mesa, shimmering like a heatwave as an alpenglow seized the La Sal Range after a long rainstorm had broken the desert's fever of 104. We stood quietly watching the last light of day extend itself across the valley—when suddenly, a pink rainbow appeared arching over Round Mountain as if this was the celestial path that brought June Birdie Kimball to Earth. What indominable spirits these babies must be to choose to be born during a global pandemic.

Life and death—there is never one without the other.

This morning saw the first federal execution in seventeen years. The United States of America sanctioned the killing of a prisoner on death row. It was reported by CNN which I heard on the radio: "Daniel Lewis Lee, a convicted murderer, was executed Tuesday morning...after the Supreme Court issued an overnight ruling that it could proceed. Lee was pronounced

dead by the coroner at 8:07 a.m. E.T. in Terre Haute, Indiana. His last words were "I didn't do it. I've made a lot of mistakes in my life but I'm not a murderer. You're killing an innocent man." Attorney General William Barr said Lee "finally faced the justice he deserved."

"Justice Stephen Breyer, joined by Justice Ruth Bader Ginsburg, reiterated in one dissent something he has said before: he thinks it's time for the court to revisit the constitutionality of the death penalty."

"Earlene Peterson—whose daughter, granddaughter and son-in-law were tortured, killed and dumped in a lake by Lee and an accomplice—has opposed Lee's execution, telling CNN last year that she did not want it done in her name."

And Justice Sonia Sotomayor, joined by Justice Elena Kagan and Ginsburg, wrote separately to criticize the court's "accelerated decision-making." Sotomayor went on to say, "The court forever deprives respondents of their ability to press a constitutional challenge to their lethal injections."

In 2019, Barr moved to reinstate the federal death penalty after a nearly two-decade lapse.

Meanwhile, Covid-19 continues to spike in thirty-nine states with Miami–Dade reporting a hundred per cent of their ICU units are now full. Florida has had over 10,000 new cases of the virus in recent days and Disney World is reopening today. This "president" continues to say we are doing great.

We are not great, Fazal, we are entitled Americans who see ourselves as the exceptions and exceptional. No one will tell us what to do. No one will tell us we have to wear masks or stop going to bars or churches or movies or whatever impulse we choose to act on. We are exempt, apparently, even from

viruses, save the 135,000 fellow citizens who have died or the three million of us who have tested positive! Schools are set to open next month at the urging of Secretary of Education Betsy DeVos, who says only 0.2 per cent of the children will die, never mentioning that the data translates to 14,000 children dead of Covid-19 when the schools open.

This may sound like a rant, but it is simply another day on the coronacoaster.

I stare at the three women you photographed in Malawi in 1994, Sarah, Maria, and Shika, the wives of Kulaso Whisky. Are they alive or dead twenty-six years later? What would their faces reflect now?

Headlines on May 19, 1994 in the *New York Times* read: "Dictator Said To Be Trailing In Malawi's First Open Elections." I read quickly through the article, "Early returns showed Africa's longest-ruling dictator trailing his opponents today in Malawi's first multiparty election, officials monitoring the returns said.

"President H. Kamuzu Banda, who has ruled since independence from Britain in 1964, was far behind a former political ally, Bakili Muluzi, and slightly behind Chakufwa Chihana, a labor leader and former political prisoner, officials at the government-run broadcast authority said."

Banda lost.

Would these women have cared? What were their concerns? You tell me they are refugees from Mozambique. How do politics affect their lives? If they are in this camp in Nyamithuthu, Malawi, because of war, they are in this camp because of politics, dictators, and power.

I suspect these "sister-wives" as we call them in Utah, know about plagues, pandemics, and contagions that kill like cholera.

I found in *Epidemiology & Infection*, June, 1997, that in 1990 between August and December:

> an epidemic of cholera affected Mozambican refugees in Malawi causing 1931 cases (attack rate = 2.4%); 86% of patients had arrived in Malawi < 3 months before illness onset. There were 68 deaths (case-fatality rate = 3.5%); most deaths (63%) occurred within 24 h of hospital admission which may have indicated delayed presentation to health facilities and in adequate early rehydration. Mortality was higher in children < 4 years old and febrile deaths may have been associated with prolonged i.v. use. Significant risk factors for illness (P < 0.05) in two case-control studies included drinking river water (odds ratio [OR] = 3.0); placing hands into stored household drinking water (OR = 6.0); and among those without adequate firewood to reheat food, eating leftover cooked peas (OR = 8.0).

These statistics from "Epidemic cholera among refugees in Malawi, Africa: treatment and transmission," authors, D. L. Swerdlow, G. Malenga, G. Begkoyian, D. Nyangulu, M. Toole, R. J. Waldman, D. N. Puhr, R. V. Tauxe.

Did these three women suffer the deaths of their children? Did they lose family members? How long have they been in Malawi? How long will they stay? The uncertainty of mobile people becomes the constant like death and disease. In America, denial is our certainty. Complacency follows. Arrogance and ignorance are bringing us to our knees as the coronavirus cases keep rising, with Death walking into the rooms where people lie unable to breathe.

These three women are seated on a bench, shoulders touching. I am drawn to their hands brought together on their laps,

fingers cradled in the other, thumbs touching, one woman hides her right hand behind her elbow, her left arm outstretched, her hand resting on her knee; all their feet are placed on the mat, ready to stand. Their eyes are steady, looking forward like their feet. Their clothes are pleasant, patterned with stripes, polka-dots, and squares. Two of the women wear hats.

Physical distancing is soul-separating. I miss the people I love. If we are together, we are masked. If we care about each other, we stay away. Self-quarantine is an act of love. But I love being together. I long to sit on a bench with my sister-friends, Alexandra, Ida, and Janet. All of us so very different. Country, race, class. What brings us together are our shared experiences through our children, our concerns, our histories.

A Sense of Common Ground, your words, not mine. This is what I want to know: What constitutes common ground? A place, a people, a purpose? The air we breathe, the water we drink, a shared sky with clouds and stars and the blazing comets that shine before us like dreams? Or maybe it is a livable future reserved for our children, the generations who will follow us like the girl standing in the background against the wall watching.

Common ground is what I miss in our home country, Fazal, a sense of a shared vision of decency and dignity and equity for all with a commitment toward planetary health beginning in our own communities. I wish we could hold each other tight, a simple and necessary embrace to acknowledge what we are losing, missing, yearning for in our bones.

I am lingering on the page because I am lingering with these women, Sarah, Maria, and Shika. I am a voyeur across the continents looking at them with a longing to know who they are and if they were able to return to Mozambique. They do

not see me. But they see you and you are seeing them through the lens of your camera. They trusted you to bring them home to a world and a community who cares for more than their own comforts.

Thank you, Fazal.

Bless you and Alex and all the ways
you take care of those you love,
Terry

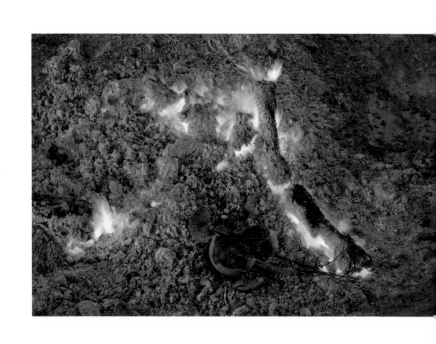

Dearest Fazal,

The cremation fields in Benares, India, reach me in color as you
intended. It is elemental, sensory like the swirling of smoke.
A suffocating limerence. I smell fire consuming flesh. My hands
are holding the heat. If I close my eyes, I can still hear and listen
to the flames licking the last remains of my own brother's body
burning not on a pyre, but in a retort.

We are Earth.

We are Fire.

We are Water.

We are Air. all
 is
No more. We always want more. that
We are sparks of breakaway light dissolving

Love,
Terry

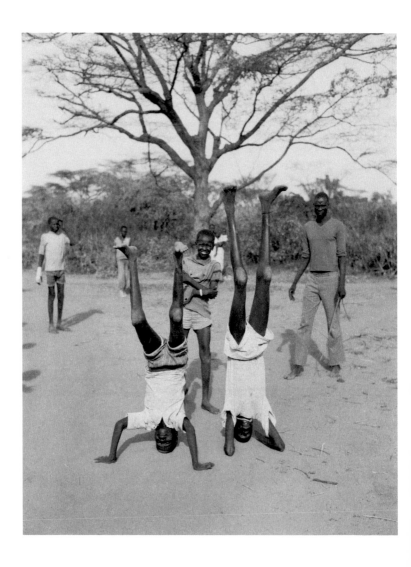

Dearest Fazal,

Standing on one's hands! What a perfect idea. Standing on one's hands with a friend is an even better one—with an audience to boot as these men are barefoot. Joy is oxygen (isn't it), especially in moments when we think we can't take one more breath, or another step forward. Why not invert the whole situation with goodness and laughter, when you have an audience like these two? If the world feels like its upside down, then make it so.

This is the Hangman in the Tarot deck, "the twelfth card of the arcana that suggests ultimate surrender, sacrifice, or being suspended in time."

Just for fun, I turned this photograph upside down. The two young men are now holding up the earth with their hands, each like a modern-day Atlas revisited. Their legs are suspended in air until you start wondering if the boys aren't now holding up the sky as their legs leap for joy as the roots below are exposed. Who is to say any more what is real and what is imagined? What is fact and what is fiction? And perhaps most importantly, we need to ask the question of where do we stand in a world made of quicksand?

I stand on the solid ground of synchronicity, Fazal. I trust the electricity that comes when the inner and outer worlds merge so perfectly that you can only bow to the perfection of that serendipitous moment when a bridge of connectivity has been made.

On the day family and friends were gathering in Kayenta to honor, mourn, and celebrate Jonah's son's life, I received a call

from Ken Sanders, who runs a bookshop in Salt Lake City. Ken and I have been close friends for more than four decades. He called me and said that he had just purchased a large library from someone in Arizona and tucked inside one of the boxes of books was a consortium of feathers—he believed they were eagle feathers.

"What do you think I should do with these?" he asked.

I said it is illegal for a white person to possess eagle feathers, or for that matter any feathers that belong to birds of prey. When I worked at the Utah Museum of Natural History, we would call an officer at the Division of Wildlife Resources or consult a Native elder.

Jonah Yellowman came into my mind. I thought of his son who had just passed. I paused. I shared with Ken that Jonah was the spiritual adviser for the organization called Utah Diné Bikéyah and a strong advocate for Bears Ears National Monument. I told him he was also a medicine person for the Diné, and that his son had died from the coronavirus and they were gathering for his funeral as we were speaking.

"Perhaps these eagle feathers are meant for Jonah," I said. "My instinct says they should go to him."

I then offered to talk to Jonah. Ken said he would carefully wrap them together and mail them to me.

Today, the package arrived. I called Jonah to share the story of the eagle feathers and asked if he would like to see them or could use them in his ceremonies.

There was a long pause.

"We are honoring my brother today. It's crazy," he said. "First my son, then my brother. It's not fair."

"No, it isn't," I said. "I am so sorry, so deeply sorry, Jonah."

I asked if his brother's death was also from Covid-19. He said no, that his older brother had been sick for some time.

"Are you sure they are eagle feathers?" Jonah asked.

"I have only seen a photograph. Would you like me to open the box and verify that they are eagle?" I asked.

"Please," he said. Jonah knew me well enough to know I loved birds and could properly identify them (unlike the mystery bugs in Bluff, dear Fazal, I know what you are thinking).

While Jonah waited on the phone, I opened the cardboard box Ken had sent with the feathers carefully wrapped in white paper secured inside. I brought the white package on to the table, gently unwrapped it and when faced with the feathers, I was stunned by their beauty and power.

Twelve eagle feathers appeared as a vision. They were large broad wing feathers clearly ceremonial. The shaft of each feather, twelve to fourteen inches long, had been covered at the base with red felt with strands of small royal blue beads attached to white buckskin ties wrapped around them.

I took three pictures and sent them immediately to Jonah. It took some time for them to reach him as our cellphone reception is slow here in the outback.

"Nothing yet," Jonah said. "Nothing yet. I think you're playing a trick on me," he said laughing. We kept waiting together until he said, "Got them." He looked at the pictures of the feathers and was silent for a long time.

"Yeah, they belong to eagle," he said, "but what's that they've been wrapped with?"

I described the shaft coverings of red felt and blue beads.

"Hmmm—Go ahead and send them," Jonah said. "That is so interesting. Yeah, just send them to my P.O. Box in Kayenta."

He paused. "That's really interesting. I'm going to have to think about this. Thank you."

After giving Jonah my word that we would send the feathers tomorrow, I sent him my love and told him once again how sorry Brooke and I were for his losses.

"I know." he said followed by another long silence. "I am okay. It's just the way it is right now."

The world is upside down, and we feel turned inside out, exposed. We are standing on our hands to see if another point of view might reveal itself. No, we are standing on our heads because we need to locate joy if we are to survive the darkness we are inhabiting globally, be it a refugee camp, a cage at the American–Mexican border or a national quarantine order to shelter in place.

We can no longer look for leadership beyond ourselves. It is no longer about asking for permission, but rather accepting what comes to us. We can take a stand with others, even if others see us as fools and contrarians during a crisis. We can dare to believe in the messages that come when feathers appear with a desire to fly home.

Missing you,
Terry

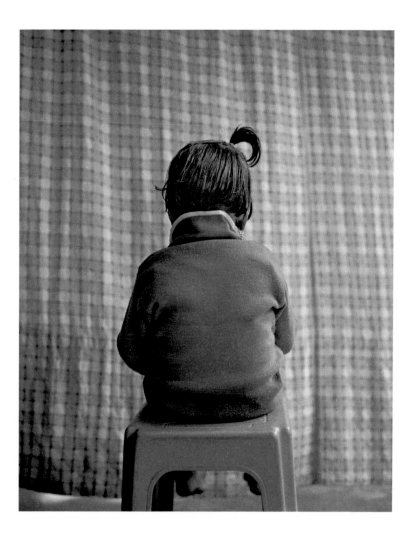

Dearest Fazal,

Hidden. This is the word that comes to mind with this image
of the child facing a plaid curtain. Hidden. You tell me this
is a child of a sex worker in India. I want to know more. I do
my research and find the numbers of women working in the
sex trade varies wildly. One site says there are as many as two
million sex workers in India. Another source says it is closer to
ten million. And still another more conservative organization
says there are roughly 700,000 women working as prostitutes,
though that word is now being retired.

 Hidden. This profession. Legal and illegal, at once, in every
town, city, and country around the world. Who draws the line
on the map of a woman's body?

 Here is a story: Manju Biswas was a prostitute from
Calcutta. She did not enter her profession by choice. She was 13
years old. In a 1999 *Newsweek* interview, "She says an unscru-
pulous neighbor lured her to Calcutta and sold her for $30 to a
brothel keeper. The child was drugged, raped and put to work
in the sex trade." She went on to describe how, "These men, 10
to 15 a day, would come visit me." Whenever she managed to
scrape up a little cash, a gang of local punks would bully her,
rough her up… "If I protested they would not only take away
my money but stub out cigarettes on my face and arms."

 The interview revealed that in time, Biswas joined with
other girl sex workers and they fought back on the streets,
sometimes brutally. They won respect. They organized

themselves. The women of Sonagachi formed a cooperative which enabled and empowered the girls to keep half their wages usually taken by a madam or pimp. Together, they advocated and lobbied on behalf of their "health and welfare." Respect came with a change in terminology from prostitutes to sex workers. Twenty years ago, there were 30,000 sex workers in their organization. Today, I can only imagine how their coalition has grown as there are now chapters throughout India.

I find this story hopeful but it, too, was hidden. I had to look for it. Manju Biswas spoke. When one woman speaks, other women speak and follow. They organize. It is isolation that is withering. An inner room dark without windows.

Women. Children. A child turns her back. What does she understand of her mother's work? Will she choose the same profession, or will it choose her by fate or necessity or both?

What is the price a sex worker pays regardless of the money she earns each day, every night for her services? And what price does every woman pay regardless of who she allows to touch or enter her body? Tell me when does pleasure turn to violence? When does violence force a woman to leave her body and watch from afar a woman who shares her same name cry out in terror?

I wonder, Fazal, if I had not turned the photograph over to read your hidden script, what story would I have imagined from this child's gestalt?

The pigtail. The story mothers and daughters know well: the morning ritual of a mother combing her daughter's hair that leads to the fight over who is in control. My mother pulled my hair so tight when she was twisting it into a bun, sometimes my vision would blur. Sometimes I cried because I wanted

it one way and she wanted it another. Sometimes I won, but mostly, I lost. It was my mother who decided if I would wear a ponytail or pigtails or braids, one or two. I see this same tug of war in my granddaughter Malka when her mother takes the time to braid her hair into cornrows or a make a little knot on top of her head. Malka will resist. Her mother decides. But when it's done, Malka looks adorable. The child in this photograph whose name is Rani has a mother who cares. Her singular pigtail tilted to the side is an act of originality.

What can art tell us that facts cannot?

In this portrait, I see a child who knows how to inhabit the hours she is left alone. Poise becomes her. Her back may face you as a photographer or me as a viewer, but her focus is on what her hands are doing, that only she can see. Hidden. Hidden to us—just as what is behind the plaid drapes is hidden to her.

I can imagine Rani's dangling feet which are bare, swinging back and forth at times as she sits dutifully on a plastic stool. Though she may feel restless, she remains in control of her body. She is not solitary. Her imagination is her companion directing the activities of her hands, as she waits for whom-ever will come out from behind the drapes.

But what makes this picture threatening, Fazal, is your gaze, even as a kind and respectful artist with an eye on our shared humanity. You have her back—until she turns around. Then suddenly, the encounter becomes what it always becomes between a man and a child or her mother: Power.

Always,
Terry

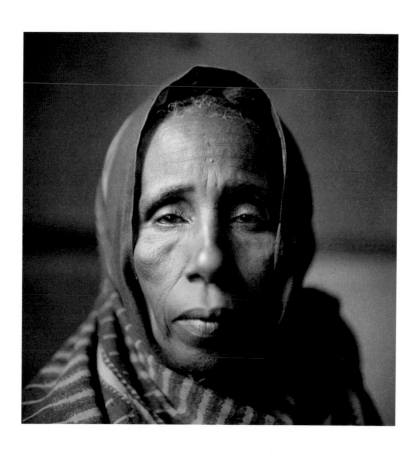

Dearest Fazal,

Saladho Hassan Ali is a woman I wish I knew. The character in her face is where I locate hope, a word I don't use lightly or often. What she has seen in her life is held in her eyes. To be able to look so directly into the camera is the kind of knowing I wish to possess. She trusts you. I can imagine there is much in her life she does not trust.

You tell me that this portrait was taken on the day her daughter "fought off an attacker while collecting firewood." You tell me that both mother and daughter were living in a Somali refugee camp in Hagadera, Kenya, in 2000. I had to look on a map to see where this camp is found, and learned it is the site of three refugee camps, Hagadera, Dagahaley, and Ifo, run by the United Nations High Commissioner for Refugees, as of 2019 hosting 211,365 refugees and asylum seekers, making it the third-largest refugee complex in the world.

I knew nothing of this, Fazal.

But if you asked me where Lake Nakuru National Park is or the Maasai Mara National Reserve, I could tell you exactly where they are in the Great Rift Valley and that I had been to both. I went to see flamingos and black and white rhinos after the U.N. Decade for Women gathering in Nairobi was over. The year was 1985. I was thirty years old.

This is my privilege.

I wonder Saladho Hassan Ali's age. I cannot tell. The striped headscarf that frames her face lends further dignity to her

presence. Not only do I not know how old she is, but to what time she belongs. She feels like a woman who has stared down death. A woman who has held each child she has birthed close and each grandchild closer knowing little can protect us from our fate, save God. I believe she is a woman who knows prayer.

Last night, we learned that John Lewis, the towering civil rights figure and congressman from Georgia, has died from pancreatic cancer. He was eighty years old. The face of Saladho Hassan Ali and the face of John Lewis share a similar nobility, that of facing the moment. Lewis had an unblinking faith in the future because he was committed to fighting for it even if he died in the process. Both hold themselves with a respect that is visible, formidable and vulnerable, at once. Humility is the bedrock of strength.

"Good Trouble," John Lewis said to many of us. "Necessary Trouble." He exemplified and embodied a fierce understanding of justice, dignity, and what radical love and freedom for all looks like. That he was arrested forty times before he was brutally assaulted while crossing the bridge at Selma and suffered life-threatening injuries, is a measure of his determination that the treatment of black people must change, even if it meant his death. And yet, as Karen Bass, chair of the Congressional Black Caucus said, "[He] remained devoted to the philosophy of nonviolence in his demand for equality and fairness under the law, even to this day, as America faces another reckoning with racism and hundreds of thousands around the world spark a modern-day civil rights movement against police brutality and racial injustice."

One of the privileges of my life was meeting Mr. Lewis. It was April 7, 2003, I have never forgotten that date. America was

at war with Iraq. The poets William Merwin and Sam Hamill invited me to accompany them to Washington D.C. to present 11,000 anti-war poems written by U.S. citizens to members of Congress that would be entered into the Congressional Record. The only members of Congress who would receive these poems were the members of the Congressional Black Caucus. No one else would even look at them, let alone embrace them as an act of civil disobedience with a pen.

Congressman Lewis received the pile of poems from W.S. Merwin wholeheartedly with his fellow colleagues, Elijah Cummings, Maxine Waters, and John Cornyn, among them. I don't remember his words though they were eloquent. What I do remember was the magnetic force of his spirit.

"Look those who would harm you in the eyes," he wrote in his memoir, *Walking With The Wind.* "Let them see your humanity." John Lewis's autobiography changed me. I often think about the story he told of being at this grandmother's place in rural Georgia with his siblings and cousins. A hurricane was predicted. The winds were already blowing strong. John's grandmother said, "Children, you must follow me for the duration of the storm, wherever the wind blows, we will walk toward it. When the wind threatens to lift this corner of the house up, we will walk toward it; when the wind walks to the opposite corner of the house, we will walk toward it. And if it threatens to blow the house off its foundation—we will make a circle in the center of the house to hold the house steady."

He said that for hours the children "walked with the wind" across the rickety floorboards, walking from one corner of the shack to the next, holding it to the ground. It was here he learned the lesson of working together in community,

especially in times of danger and uncertainty. The house remained intact.

When John Lewis said repeatedly, "Don't ever give up," I can imagine Saladho Hassan Ali and her daughter have voiced these words to each other. Perhaps, this is one of the reasons her daughter was able to stave off her attacker. She wouldn't give in or give up. She knew her strength.

The Kenyan activist Wangari Maathai lived a similar credo, to never give up, to work together. She remains one of my true heroes. No doubt, you know of her, Fazal. Her belief went beyond hope. It was rooted in action. Like Lewis, Maathai was beaten by police and suffered physical attacks for her protests against President Daniel Arap Moi's government, including its plans to build a sixty-story government building in the middle of Uhuru Park in central Nairobi. She was jailed on multiple occasions for her resistance, also for contempt.

When she died in 2011, the *Daily Telegraph* reported in her obituary that her husband's reasons for divorcing had been, as she said, because she was "'too educated, too strong, too successful, too stubborn and too hard to control.'" And perhaps the court agreed. When she called the judges "either incompetent or corrupt," they promptly slapped her in jail for six months for contempt of court."

I met Wangari Maathai at the U. N. Decade for Women in 1985, not inside the conference, but outside. She was not part of any delegation. She was not on anyone's agenda. She was her own sovereign speaking on behalf of Kenyan women who were gathering firewood and water eight to ten hours a day to feed their families. She was speaking about deforestation and the need to plant trees. She was speaking about the empowerment of women.

Wangari Maathai had founded a seedling organization in 1977 called "The Green Belt Movement." Few were listening. I stayed. I heard truth being spoken. I saw character and courage and leadership. I left the formal meetings I was assigned to attend and followed her into the villages where women were gathering seeds in the folds of their skirts and planting them. I came home so inspired I started a tiny offshoot organization called "The Green Belt Movement of Utah." Almost two decades later, in 2004, Wangari Maathai would become the first African woman and environmentalist to receive the Nobel Peace Prize. At that time, the Green Belt Movement was responsible for planting forty-five million trees in Kenya and seven billion trees through the United Nations program she sanctioned.

In 2005, I met John Lewis again, this time with Wangari Maathai. She had invited me to attend the NAACP gathering in her honor. Both she and Mr. Lewis spoke about the imperative to act in the name of justice. Lewis spoke of civil rights as human rights. Wangari Maathai spoke of justice for all, and how the rights of women are intrinsically connected to the rights of a healthy environment—how social justice and environmental justice go hand in hand. Both of these icons were sowing seeds of a moral imagination.

I return to this portrait of a woman I do not know, but a woman whose eyes create a lens through which dignity and strength is found. For me, her presence creates a threshold of enduring grace in the midst of suffering. I see an indomitable spirit and at the same time, a weary one. After any fight, exhaustion follows. After exhaustion, you are introduced to your will.

It was thirty years since Wangari Maathai and I had seen each other. After she won the Nobel Prize, she came to visit

us in Castle Valley with her son. It was a joyous reunion. We both wept. She said she was exhausted, but she knew her message of peace on behalf of women and the environment had to be heard. This was her calling. She also knew that after fighting so hard for the rights of both, when the open space of democracy revealed itself, she had to step inside it. She became a minister of the environment in Kenya.

To stand in one's power, even when oppressed. To imagine a life for yourself that others said you did not deserve. To be defiant, dedicated, and determined to live a dignified life no matter how weary, no matter how far you must walk and for how long until you can rest. This is what I see in your portrait of Saladho Hassan Ali—and she led me to two other portraits of dignity and consequence in the name of Black Lives that matter.

The light on her face, Fazal, is transcendent.

With love,
Terry

Dearest Fazal,

Everything about this image before me is beautiful—the funeral pyre cut, stacked, and built for Kulprasadh Subba, his body draped in white cloth with care, the necklace of marigolds that adorn him in death, and a celebration of his life that is about to be ignited as his flaming body is sent downriver. The four pliable stalks of plants that secure his body with ropes mirror the verdant landscape that will witness his undoing on either side of flowing waters.

So tell me Fazal, why did I almost immediately distract myself with the music of Janis Joplin? I went from entering your serene documentation of a body on a pyre to watching Joplin sing her bluesy guts out on stage at the Monterey Pop Festival in 1967 where she sang "Ball and Chain," solidifying herself as a woman with the trembling voice akin to aftershocks of an ongoing earthquake.

Why?

Because if I follow my thoughts of a life on fire, I think of Janis—how she burned hot and bright like a meteor with all the cosmic speed and flare of being a rock star and falling just as fast with an overdose of heroin at twenty-seven years of age. But my god, how she sang. Maybe coming from a family where most of the women died young from cancer, I saw in her a guiding light who exemplified in the extreme how to give all you've got to all you do, even if in the end it kills you. I think I learned from listening to her albums over and over which I still

do that death doesn't matter as much as the passion you bring to your life does.

Janis Joplin died on October 4, 1970. I was in high school. My mother was about to be diagnosed with breast cancer with a prognosis of less than two years to live. I would no longer feel safe. I would no longer be able to count on anything because what I counted on was my mother to live forever. This was a lie. No, this was my fantasy. Death became my haunting until I realized I would live my life so fully, I would not fall prey to fear, I would just defy what scared me by using my voice like Joplin did when she sang "Ball and Chain"—how she sang that song would be how I would sing my life and survive whatever would keep me shackled unable to move forward be it death or loss or loving what wasn't good for me. I would find something to serve larger than myself because myself was just a body meant to be burned. So much for taking care of myself. I would take care of others like Janis Joplin took care of me. She is still burning bright as the dead do by those who loved them.

They say that when Joplin would perform "Ball and Chain," she would often improvise at the end of the song with the lines "Love is such a pain, love is such a pain," her voice reaching a repetitive and ecstatic pitch and fervor that would collapse the audience into a state of rapture.

I turn to another artist who burned bright for me, Johnny Clegg, who died a year ago almost to the day. The South African musician and dancer sang a song called, "Dela."

Here are the lyrics:

I've been waiting for you all my life, hoping for a miracle
I've been waiting day and night, day and night

I've been waiting for you all my life, waiting for redemption
I've been waiting day and night, I burn for you
A blind bird sings inside the cage that is my heart
The image of your face comes to me when I'm alone in the dark
If I could give a shape to this ache that I have for you
If I could find the voice that says the words that capture you
I think I know, I think I know
I think I know, I think I know
I think I know why the dog howls at the moon
I think I know why the dog howls at the moon
I sing dela, dela
Ngyanya, dela
When I'm with you
Dela, sondela mama
Sondela, I burn for you

Sondela in Zulu, a language Clegg spoke, is both a name and a verb that translates to "approach." How do we approach our lives? How will we approach our death as death approaches us? When I hear the words "*I burn for you*," I want to burn for what is good and right and just in the world. It is beyond human love, though not apart from it. I want to write my words on the page until the pages ignite with what is beautiful and hard and true.

That could be a definition for the comet NEOWISE suspended in the night sky just after dusk. It is a harrowing presence made of rock, ice, and dust that measures three miles across, traveling at about 40 miles per second, that translates to 144,000 miles per hour with two tails streaming through space. The comet became visible on July 3 and will be brightest on July 26, then gradually fade out of view. Without binoculars

or telescope it looks like a smudge of stardust slightly above the horizon in the northwest corner of the sky—near the Big Dipper. I see it best with my peripheral vision—a side glance with my naked eye. We have watched it nightly for most of the month knowing it will be another 6,800 years before it travels this way again.

"Tyger, Tyger, burning bright…" I might as well bring Blake into this mix, a comet in his own right, alongside the rock stars Janis Joplin and Johnny Clegg. My grandmother read this poem to me as a child and we memorized it together, it returns to me now:

Tyger Tyger, burning bright,
In the forests of the night;
What immortal hand or eye,
Could frame thy fearful symmetry?

In what distant deeps or skies.
Burnt the fire of thine eyes?
On what wings dare he aspire?
What the hand, dare seize the fire?

And what shoulder, & what art,
Could twist the sinews of thy heart?
And when thy heart began to beat,
What dread hand? & what dread feet?

What the hammer? what the chain,
In what furnace was thy brain?
What the anvil? what dread grasp,
Dare its deadly terrors clasp!

When the stars threw down their spears
And water'd heaven with their tears:
Did he smile his work to see?
Did he who made the Lamb make thee?

Tyger Tyger burning bright,
In the forests of the night:
What immortal hand or eye,
Dare frame thy fearful symmetry?

The world rarely makes sense. This letter may not make sense to you, but I am following where your images lead me, Fazal. I trust you as the people you photograph trust you. It's all about the relationship. In this way, there is always the surprise, not knowing where we are going, but the pleasure of trusting where we will be taken—even if the journey is internal.

I am tired of writing in a way that is orderly and symmetrical, easily understood, pleasing to the eye. Nothing is ever equal on both sides of anything. Balance is momentary, not a permanent condition. And maybe not even preferable. As much as we want to believe in equality, even the symmetry between life and death, I believe it is an aspiration not an abiding principle. Asymmetry is closer to the path I follow—crooked, irregular, arresting, a disturbance. There is an asymmetrical truth to this picture that moves me, and it begins with the eroding banks of the river.

Kulprasadh Subba will be set free downriver as he follows the way of his ancestors as they followed theirs. Here are the questions you have brought me to: Will the eyes of the tiger watch his body erupt in fire and follow him downriver? Will

his fleeing spirit ride on the back of an orange and black tail, another kind of flame in the night? What is passion but the risks we take in the making of our own "songs of experience"?

There is no such thing as death. We simply shape shift into other forms until we are a smudge of stardust best seen as a glimmer.

In the preparatory drama of this photograph, I hear the voices of the Dead singing through the living, anticipating their seismic and stellar approach.

Love,
Terry

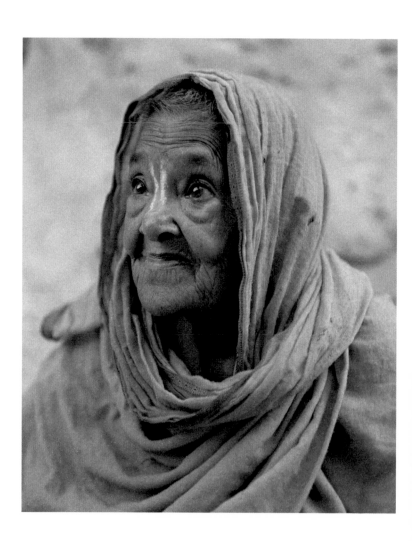

Dearest Fazal,

How do we stay open—open-minded, open-hearted, eyes open, bright with light? If you were to walk inside our home that you know so well, you might be surprised by the darkness we are courting in the height of summer. The doors are closed, the blinds are down and shuttered so no light can enter. Fans are whirling in each room, trying to move the hot air that is heavy and suffocating at 107 degrees outside and rising. We are in the midst of a "megadrought" as reported in the *New York Times* last week. In case you missed it, this paragraph struck me:

> The Southwest has been mired in drought for most of the past two decades. The heat and dryness, made worse by climate change, have been so persistent that some researchers say the region is now caught up in a megadrought, like those that scientists who study past climate say occurred here occasionally over the past 1,200 years and lasted 40 years or longer.

Brooke and I have taken to filling up bowls with water and placing them on the edge of the porch for parched birds like mourning doves and brown thrashers not usually seen here. We have put out bird baths in the grove of cottonwoods for the smaller birds like the Say's phoebes and black-throated sparrows. It's grim, Fazal. For those who deny the heating up of our planet, I welcome them to come sit on our porch and see how long they will last before coming inside our makeshift cave.

The nights are our breathing space where the coolness of the Milky Way with its sweep of stars above brings a respite from the heavens. When I look at your portrait of Chandra Bhaga ("*Half-moon*" you write in parenthesis) with her eyes wide with wonder looking upward, I feel her companionship. The fullness of her face with an amused grin holds a sense of devotion bound to faith. At least this is how she is speaking to me at a time when our days within this pandemic are largely solitary. She reminds me to seek lightness and joy in the way kittens do as they try to grasp what is just beyond their reach.

You tell me Chandra Bhaga is another widow from the ashram at Vrindavan, the city of 10,000 widows who gather for solace and solidarity having been shunned by their families and are now outcasts to the place they once knew as home. I read that in the last few years, the widows who gather here no longer must consign themselves to wearing white saris as a sign of mourning. Many of the widows now are draping themselves in colors and are invited by the community to celebrate in the festivals where the colors of fuchsia and marigold paint their bodies.

We painted our bodies last night in Mary Jane Canyon with sand, terracotta orange, wet from a quick and violent downpour. We couldn't help ourselves. We danced in the mud with our hands joyously raised over our heads welcoming the rain—oh the smell of that rain, Fazal, in a word: *petrichor*.

Perhaps this is how we stay open by being present wherever we are, even in drought, especially in drought in grief in exile. My grandmother's last words before she died were three: "Dance, dance, dance."

It takes faith to dance at the threshold of death. It takes faith for a widow to look upward at God and believe there

is something for her beyond the sorrow of a shattered heart. Chandra Bhaga wears her faith loosely, intimately like the scarf draped over head and across her shoulder. The light in her eyes tells me all I need to know here in the baked and broken landscape, isolated and lonely.

Thank you, my friend,
Terry

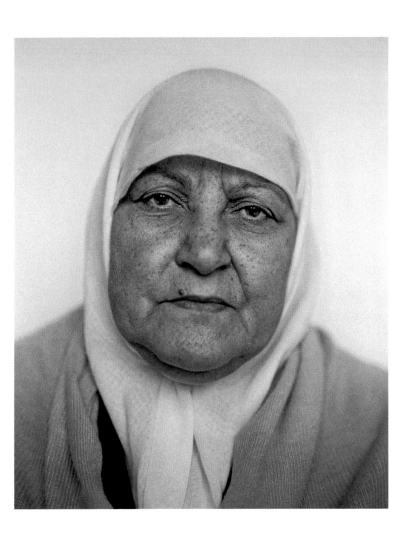

21 JULY 2020

Dearest Fazal,

Thank you for an engaging text conversation this morning, where we could be candid about our concerns regarding the police state Donald Trump is creating under the guise of "law and order." I appreciated you sending me the actual "Executive Order on Protecting American Monuments, Memorials, and Statues and Combating Recent Criminal Violence" signed on June 26, 2020. This is indeed terrifying, as you say, and it pays to read the actual language. I wonder if the gutting and desecration of Bears Ears National Monument from Trump's actions on December 4, 2017 would fall under his criteria of violence? Particularly this clause:

> Sec. 2. Policy. (a) It is the policy of the United States to prosecute to the fullest extent permitted under Federal law, and as appropriate, any person or any entity that destroys, damages, vandalizes, or desecrates a monument, memorial, or statue within the United States or otherwise vandalizes government property. The desire of the Congress to protect Federal property is clearly reflected in section 1361 of title 18, United States Code, which authorizes a penalty of up to 10 years' imprisonment for the willful injury of Federal property.

What we are witnessing right now in Portland, Oregon, is a government takeover of the streets and a violation of our constitutional rights as citizens to assemble and to peacefully protest our government. Unidentified federal agents dressed

in camouflage trolling the city in unnamed vans are arresting people, detaining them without cause, interrogating them, and then returning them to the streets terrorized.

As reported in the *Washington Post*, "Portland Mayor Ted Wheeler twice called the federal police in his city President Trump's 'personal army' and said that he is joining a chorus of Oregon's elected officials in sending a clear message to Washington: 'Take your troops out of Portland.'"

The poet Jorie Graham tweeted this afternoon, "Be outraged. Be terrified. Wake up. It's a coup. What part...do we not grasp. This is not really really really bad government. This is a hostile takeover...A plot against America. It's a bloody internet-fueled civil war & images of violence in streets r porn to many."

I feel like we are a country of frogs, slowly being boiled alive without realizing what is happening to us. It took a "Naked Athena" to get the nation's attention and confront the madness of this violence. An unidentified woman wearing only a black knit cap and face mask approached an armed line of federal soldiers in downtown Portland. As she walked toward them holding their gaze, she then sat down in the center of the street, raised her knees to her chest and struck a yoga pose the goddess Kali would be proud of. The federal troops were defenseless against one naked woman who sat before their wall of munitions and spread her legs wide open. The gunmen in army fatigues could do nothing but look—and remember where they came from.

There are many forms of resistance. I believe in disobedient women.

The two women you introduce me to today, Fazal, were born in 1955. So was I. You know this is a shared year among us, and so you provide me with a mirror. Although we live in

worlds apart, I believe much unites us. Over tea, we would come to see our hearts open to the truths of our lives. These women are unnamed. I will call them my sisters.

Let me move closer. You tell me one woman is from Israel; one from Palestine. One has dark, short, curly hair; the other wears a white hijab that frames her face. One has light eyes—I imagine hazel-green; the other has dark eyes, brown. They both have down-turned mouths. I cannot call them smiles. These women know sorrow. I can see loss lodged in their eyes.

In 1955, the year we were born, Palestinian Arabs were still being engaged in the forced exodus from their homelands that began during the 1947–49 Palestine War. History tells us that between 400 and 600 villages were destroyed. The "Nakba"—or the "catastrophe"—refers to the height of the war in 1948, when more than 700,000 Palestinians fled or were expelled from their homes. In May 1948, the Independent State of Israel was proclaimed. The conflict between these two adjoining states continues as does the Israeli occupation of Palestinian settlements.

As an American, I have unwittingly contributed in inexplicable ways to the stories of political and physical separation between Israel and Palestine. The United States has a long track record of supporting the Israeli military. Everyone says the conflict between Israel and Palestine is "complicated," in other words better left alone. There are strong feelings on both sides. But most people I know, such as yourself, Fazal, are pro-Palestinian, believing they have a right to return to their own homeland.

In a strange series of events on September 13, 1993, some friends and I who were in Washington, D.C. for "Wilderness Week" to lobby Congress on the importance

of Utah wildlands, were invited by our Congressman Wayne Owens, who had worked for decades on issues in the Middle East, to attend a reception for the Israel–Palestine Peace Accord signed by Shimon Peres and Mahmoud Abbas that afternoon with President Bill Clinton overseeing the historic agreement. Congressman Owen feared the turnout might be low. We went and I remember on a visceral level the hope that infiltrated that occasion.

I can't help but wonder what the conversation would have been had I met my sisters under that tent twenty-seven years ago when we were thirty-eight years old. Would they have shared a vision of hope? Or would there have been tension and resentment between us?

Now, in 2020, as we are all confronting a global pandemic, with Israel and Palestine experiencing lockdown conditions as we are in America, I wonder what our conversation would be if the three of us were to convene on our patio in Castle Valley? Perhaps we would begin talking about our relationships to the desert over cups of tea, yes, we could begin there as sisters, with a shared affection and understanding of what it means to live in an arid landscape. I would like to ask them what acts of resistance they have participated in starting in their own homes. I would want to know what binds them together; perhaps water, lemon trees, and children. I would ask them if the lines that determine their homelands are the politics that define them as women or if they denounce the occupation and settlements as the divisive work of the patriarchy? What would their thoughts be regarding a two-state solution? Or can they imagine another kind of alternative in pursuit of peace? Where would they agree and agree to disagree?

I keep thinking what forces shaped our identities by being born in 1955. Culture? Race? Class? Politics? What were each of us born into—as an Israeli child, a Palestinian child, and a child from the United States?

I was welcomed into an era of unprecedented prosperity where the weight of World War II had lifted and the "Big Buildup," especially in the American West, was paving the way for dams and suburbs alongside a revolutionary court case named *Brown v. Board of Education* that would create a threshold of equity within the civil rights movement. Born female into a politically conservative Mormon family, my acts of resistance would come later in acts of civil disobedience at the Nuclear Test Site and with my body and my pen.

I suspect the woman from Israel comes from a middle-class family, her earrings are a hint of luxury or taste, a gesture of confidence. Was she raised with a sense of belonging in Israel, as a Jew, having never known physical displacement and yet holding a history of persecution and diaspora in her blood? And the woman from Palestine, what are the stories that move inside her since her people's sense of home is a history of exile, even of physical erasure? Was she brought home to a settlement in Gaza or the West Bank? Was she a child in perpetual motion and fear? Does she wear the traditional embroidered thobe as a senior woman with a renewed pride and fervor in her identity, as one who has lived and fought for her homeland knowing the uncertainty and violence associated with being seen as Other her entire life?

These two women know war. These two women know heartache. They are women who have held the space of mourning for their families where the deaths of those they

loved seemed unbearable. These women come to know how to be alone.

When these women sat for you, Fazal, and agreed to have their portraits taken, did they know you would create a diptych where the lines between political differences would be challenged and we would be invited to see their humanity first and their identities later? Did they understand the nature of your inquiry and critique?

And if they did, how might it change them? I know it has changed me simply by reflecting on their portraits and a shared point of time when our lives began.

One day, Fazal, perhaps you will take my portrait and place it beside my sisters and create a triptych of three women's faces that honors our sixty-five years and together adds up to almost two centuries of lived experience, a collective wisdom of adaptation and resistance. I believe one of the narratives we might share is that we have learned how to live and love with a broken heart; that we are women who understand the power of land; and that each of us continues to grow in our capacity to stay with the troubles as we navigate our days with a sanguine sensibility.

Within this dance of living inside the heated conflicts that dwell in the desert, we as sisters born in 1955 have become fearless. I would like to believe that each of us in our own way has entered the ever-expanding circle of unruly women, now free to exercise our power as "elders in training." We can use our voices to cry and cry out the injustices that have ravaged our families, murdered our children, and shattered peace on the planet in the exploitation of the place we call home, including our bodies, our communities through the aggression of men who forgot where they came from—their mothers.

When I look into my sisters' eyes, Fazal, I see them asking through their indignation (unspoken, but felt) for a different way to embrace the world—daring to ask, "What does the work of non-violence look like when placed in the hands of women?"

I suspect it looks like Naked Athenas staring down lines of the patriarchy all over the world, or a "Wall of Mothers" with linked arms singing into the night unafraid of the love and labor required for change in the name of ongoing injustices. It is the living mosaic of heartfelt acts of courageous vulnerability in the face of violence that make the dream of peace possible.

In solidarity, so grateful for the depth of your witnessing,
Terry

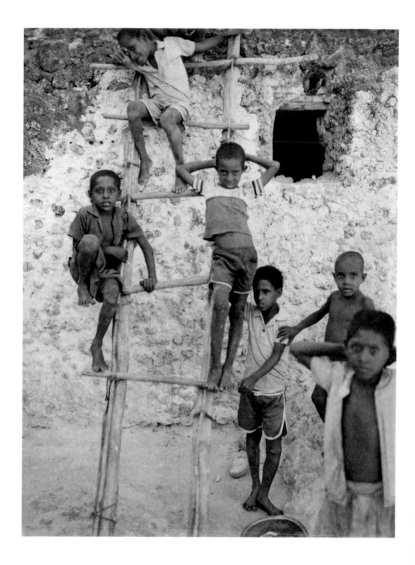

Dearest Fazal,

It is raining, always a blessing in the desert. But this morning,
it is especially sweet as Basho and Issa take their first walk in
the rain. Everything is heightened—the colors, the smells, the
clouds moving across the face of Castleton Tower. Each minute
is charged with what each kitten perceives through their eyes,
ears, nose, whiskers, tongue, and paws. I am watching lion cubs
prowl the ever-expanding territory of their home ground. In
truth, they are more like children venturing outside the house
slowly, and then, gaining confidence as they explode with joy
leaping over rocks and landing in small troughs of water that
startle them. As I write to you, they are wrestling one another
in wet sand—the kittens now pink.

I wonder what good mischief these boys will find when they
are no longer captured in your lens. Their six faces of curiosity,
fear, skepticism, distraction, terror, and surrender highlight and
foreshadow potential moves against a plastered wall of white.

Their feet tell us as much as their eyes do. One boy's feet
are perched on the wooden ladder with his hands clasped
behind his head that is bowed, chin to chest, his glamorous
body slightly curved; on the other side of the ladder another
boy sits highest on the upper rung with one foot lifted, his leg
leaning against the long side pole, his other foot balanced on
the rung below (his elbow rests on the foot of boy unseen); the
boy beneath him is sitting on the outer edge of the ladder on
the cross stick on a lower rung still, his left foot splayed on the

rung with his heel touching the backside of his thigh, knee pointing forward pulled up toward his chest, with the ball of his right foot touching the last rung of the ladder for support—his is a complicated and precarious pose; the boy standing on the ground (held in place by the hand of the smallest boy gripping his arm) has the feet of a ballet dancer placed in third position looking elsewhere; the rest of the boys' feet are hidden.

What haunts me in this photograph, Fazal, is the dark open window behind the boys—watchful like a mother's eye.

Always,
Terry

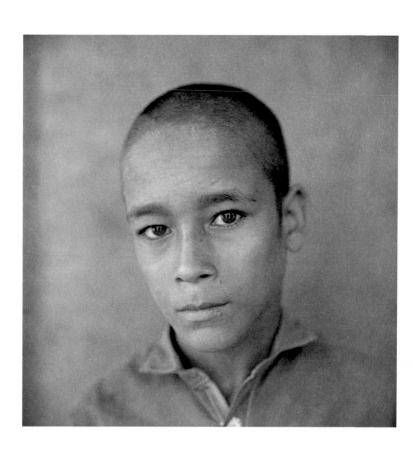

Dearest Fazal,

I have always felt this picture you made of a boy in Pakistan
was a self-portrait. I can imagine this is you in place had
your grandfather never left and your father not been born in
Kenya and fallen in love with your mother in America. In fact,
when I first saw this portrait without even knowing you as I
understand you now, I believed this to be you and that you
may have recognized yourself in this young man and he in
you, that something may have passed between the viewer and
the viewed.

Octavia E. Butler writes in *Parable of the Sower*:

All that you touch
You Change.

All that you Change
Changes you.

The only lasting truth
Is Change.

God
Is Change.

In all our conversations, both written and spoken, I don't think
we have ever discussed God, nor even mentioned the word.
And yet, I believe we hold similar ideas as to what "God" might

be or not be. But when I look at this photograph and see you in your own image, the unflinching eyes directly engaged, I feel as though I am touching the ineffable: seeing oneself in another and making beauty.

With love,
Terry

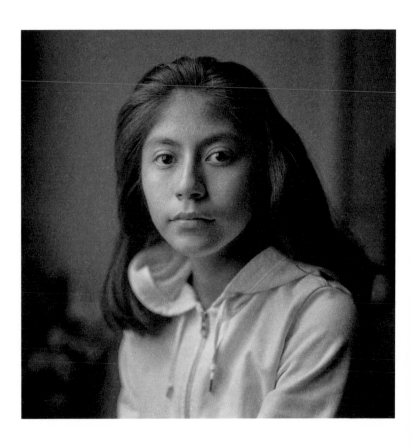

Dearest Fazal,

"Person. Woman. Man. Camera. TV." As you may have heard in Switzerland, this is the new standard for intelligence in America as stated by our "president" Donald J. Trump, who proudly "aced" the Montreal Cognitive Assessment Test (MOCA).

Memorize these five words and you get extra points. Remember the five words again after taking the remainder of the test that measures cognitive presence and you are deemed worthy of being given the keys to your car.

Let me subvert the criteria with Carina before me. She is a person. She is a young woman who imagined more from Miss Liberty than merely a Deferred Action for Childhood Arrivals (DACA). She met a man with a camera after attending mass at the Sacred Heart Chapel in Cleveland, Ohio. She was invited to sit for a portrait—which she did with an imperturbable tranquility. She is a modern Mona Lisa, not painted but photographed. In Italian and Latin, "*carina*" means "dear" or "beloved."

But there is nothing about this country of ours in this shadowed moment of craven rhetoric that promises undocumented immigrants of all ages what is engraved in bronze on the pedestal of the Statue of Liberty, that supports this kind of care, for one as strong and beautiful as Carina. This is a long sentence I have just written to mirror the long sentences of abuse now being faced by those seeking refuge in America. ICE is the cold and violent heart of the United States immigration

policy traumatizing communities at night, shattering families. Trump's wall is being erected to keep weary immigrants outside instead of inside a country of sanctuary and dreams.

These words *"From her beacon-hand/Glows world-wide welcome"* have become a farce at best and a lie in truth that shames this "Mother of Exiles," who is being asked to darken her torch and turn her back on this beloved child named Carina, even as an act of deportation is being deferred.

When I re-read the sonnet *The New Colossus* written by the American poet Emma Lazarus (1849–1887) placed on the pedestal of this great welcoming, I still want to believe there is a place for the calm heart of a young woman as dear as Carina.

> *Not like the brazen giant of Greek fame,*
> *With conquering limbs astride from land to land;*
> *Here at our sea-washed, sunset gates shall stand*
> *A mighty woman with a torch, whose flame*
> *Is the imprisoned lightning, and her name*
> *Mother of Exiles. From her beacon-hand*
> *Glows world-wide welcome; her mild eyes command*
> *The air-bridged harbor that twin cities frame.*
> *"Keep, ancient lands, your storied pomp!" cries she*
> *With silent lips. "Give me your tired, your poor,*
> *Your huddled masses yearning to breathe free,*
> *The wretched refuse of your teeming shore.*
> *Send these, the homeless, tempest-tost to me,*
> *I lift my lamp beside the golden door!"*

Let me make a prediction: The "silent lips" of this young woman named Carina will one day be speaking up and

speaking out as Congresswoman Ilhan Omar from the state of Minnesota's 5th district is doing now on behalf of the protection of DACA recipients, both as a Muslim woman and new member of the House of Representatives.

Congresswoman Omar, born in Somalia in 1982, came with her family to America where they were able to seek asylum in New York City in 1995. Ilhan would have been thirteen years old, probably close to Carina's age now. She became a U.S. citizen in the year 2000 and remains fearless with her essential voice.

"This is really a country that welcomes people and treats them like family. We don't only just welcome refugees and immigrants, but we send them to Washington," Ilhan Omar says, and she means it. Representative Omar assumed office on January 3, 2019, the same year Carina sat with you in a moment of found serenity after attending mass.

Person. Woman. Man. Camera.

I want to leave the TV off and step out from our political silos that have kept us in the stranglehold of our own convictions. We have forgotten what it means to look deeply into one another's eyes and recognize the multiplicity of our stories as an integral part of our shared humanity. Fear has isolated us. Curiosity and the capacity to care opens the latch that has kept empathy and action at bay.

It is time to reengage with our communities and protest with our hearts in the name of racial justice and equity for all. As a person of color, you know this story of racism from the inside out. As a white person of privilege, I am educating myself from the outside in. With George Floyd's murder, we have taken to the streets—black people, brown people, white people

and people of color side by side in solidarity—finally—as we
remember what binds us together, and all that has kept us apart.

•

Fazal, I retrieved our texts from when you were working in
Cleveland last June:

> *6/1/19*
> *FS: Just back from Cleveland yesterday. Trying to take a deep
> breath and then imagine a future…*
>
> *TTW: Were you happy in the end with what you made in
> Cleveland? I think we are all struggling to imagine a future. What
> we imagined, I fear, is gone.*
>
> *FS: Still awaiting the images from Cleveland. Wildly difficult,
> though I hope I may have eked out something. Most interviews con-
> ducted in Kiswahili, which was fun with Congolese from the border.*
>
> *5/28/19*
> *FS: Got thrown off of detention facilities and sweatshops for undoc-
> umented workers twice yesterday. Perfect record.*

And then, in July, you sent me these images from Cleveland. I
remember being deeply moved by the stillness of each photo-
graph, the depth of focus, yours and theirs.

> *7/20/19*
> *[4:35:13 AM] FS: Some crude images from the days of working in
> Cleveland…so many complicated stories, but such a wonderful orga-
> nization there. Full of heartening and committed staff and legal aid…*

[4:36:14 AM] FS:

[4:37:11 AM] FS:

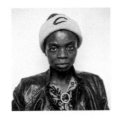

[4:38:09 AM] FS:

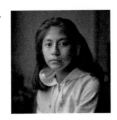

[4:40:34 AM] FS: Ranges of stories and families from Rwanda, Darfur, El Salvador, Syria, and the young DACA student above, from Mexico.

[4:42:33 AM] FS: On her last day of school in her village, her mother collected her from school and took her to her grandmother's house, and without being aware of what was happening, her grandmother sprinkled holy water on their feet, blessing them for the journey northward.

[4:45:16 AM] FS: The parish in Cleveland harbors recent undocumented arrivals in their basement...their preacher, tired of protesting in the US, visits the prisons to teach inmates their rights, and twice

yearly he travels down to San Salvador to conduct talks at schools and in communities, telling those gathered what to expect, and what their rights are if they should decide to travel northward.

[4:47:45 AM] FS:

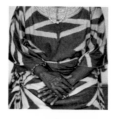

[4:49:14 AM] FS:

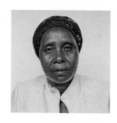

[4:51:31 AM] FS:

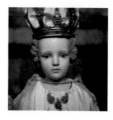

[4:52:22 AM] FS: Commissions, not again for a while…gruelling experience…

[6:28:36 AM] TTW: Dearest Fazal, These portraits are immensely striking. As hard an experience that this was, the work is exquisite. Deeply moving. And here in Cleveland. Bless you for returning home, meaning these very ununited states of america. You are needed.

[6:30:19 AM] TTW: Thank you for sharing these. Your work is singular. I cannot believe you did this in a state of exhaustion and the pressure of such a short time.

[6:39:36 AM] FS: Didn't send those along, but perhaps more important were the façades of these detention facilities, and the two companies that had experienced huge raids on the same week that separations were being conducted at the southern border…they figured attention of the media would be elsewhere. Situation is really horrifying, and several families faced with parents now deported and banned for ten years. There was such determination, solidarity, and resilience. That's what was remarkable…but taking the testimonies during the days was, as you know, terribly emotional, especially when the people are from many countries, and yet with somewhat similarly harrowing stories, and concerns of refoulement woven beneath as subtext to everything…

[6:46:27 AM] TTW: Fazal. Bless your witnessing—and your sharp, unflinching eye. If you were a bird…a Peregrine.

[6:47:26 AM] FS: Oh, then beware the mourning doves my dearest….

[6:57:41 AM] TTW: Grace. Her name. That word.

[7:04:53 AM] TTW: When does a Falcon rest?

Tell me.

With love,
Terry

Dearest Fazal,

You tell me this man (whose name I will keep to myself)
changed his clothes for this portrait to protect his privacy for
fear of "*refoulement.*"

Refoulement is a disembodied word. I say it out loud. What
is another word for refoulement? Expulsion, deportation, ban-
ishment, exile, eviction, expatriation, displacement, exclusion,
extradition. The list of synonyms can be extended: purging,
handover, ejection, extrusion, excommunication, ostracism,
relegation, proscription. The action of depriving someone, any-
one, from relief and safety due to a life-threatening situation is
an act of cruelty by a solipsistic society. Translation: "Go home.
You are not like me. You are not one of us. You do not belong
here. You are not wanted. Go back to where you came from."

When I look at this photograph, I have double vision: with
one eye I see a back turned on the needs of others; with the other
eye I see a back turned so as not to be seen at all. These are two
different individuals wearing the same black windbreaker for
protection. Both individuals are dressed in fear: fear of feeling the
pain of another, a different kind of exclusion or proscription; fear
of being condemned, removed, returned to a place where you
will die. "The simultaneous perception of two images, usually
overlapping, of a single scene or object" is the definition of dou-
ble vision. Maybe this is also a definition of empathy.

"He unzipped his hooded top and took it off, and wished
emotions were like clothes, that he could remove them, fold

them, set them somewhere," writes the poet Nick Laird. If only it was that easy. If only we could shed what rarely leaves us—the gnawing feelings of insecurity. If only those delivering the body blows and assault of deportation, the rupture and separation of families, the cold-hearted refusal to acknowledge one's humanity, if these deliverers of displacement could for one minute feel the anguish of that kind of physical and psychic pain, perhaps, these cruelties would stop.

I wonder what this man was thinking on March 27, 2019 in Cleveland, Ohio, with his back facing you. I wonder if he is here in America. Is he alive?

George Floyd is dead.

Ahmaud Arbery is dead.

Rayshard Brooks is dead.

Black men and women and children are shot every day— They are dead.

Protesters are alive on the streets as Trump's private army is throwing smoke bombs to obscure what we are seeing, believing, feeling, fearing. Democracy is under fire. Systemic racism is real. Police brutality is real. The fact is, American citizens are shooting American citizens. Breonna Taylor's ghost is haunting for justice.

I have a gun next to my bed to defend my dreams.

Yours in the questions,
Terry

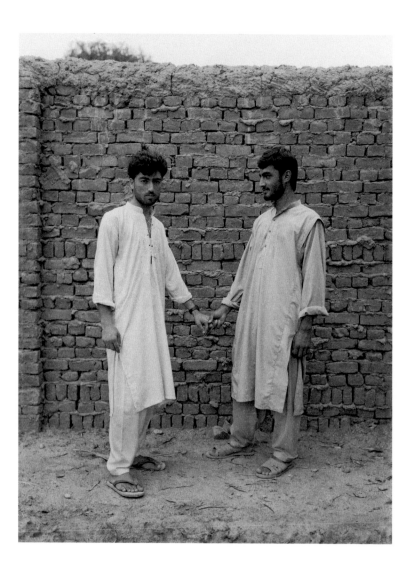

Dearest Fazal,

Today is my father's birthday. He is eighty-seven years old. He
told he me doesn't want to live. His legs can barely hold his
weight without buckling beneath him. My father is a proud
man. But then, I see how engaged he is in the world, from
politics to wanting to know each detail of each member in our
family and I think he will live through this pandemic. He was
married seven months ago and is in love with a woman named
Jan. He reads a book a day. He can quote the batting averages
of every baseball player in the national league and as a life-long
republican he loathes what this president is doing to America.
And then I recall his 40th birthday, when he said to all of us
on that occasion that he had nothing to live for—My mother
wrapped each of his presents in black.

What Does It Mean To Be A Man?

I

"By God, no brother of mine is going to die on the factory
floor," he said to the men around him. "Goddammit, help me."

II

"He's not a dog," the man said to his wife as they were driving
home late at night.

"He's a little boy in a brown dog suit." The dog-boy turned
to the woman and snarled a grin.

III

"Forgive me," he wrote to his daughter and then lit another cigarette. There, he had said it, no need to mail the letter.

IV

"Gentlemen, I appreciate the fact that my sons brought you to the house to talk to me about moving to the retirement home. Your presentation was impressive, but I'm not going anywhere." He snapped a match off his fingernail. A week later he died in his own bed and was buried with his ham radio set.

V

"I said I don't want to talk about it—"

Women, most women, always want to talk about it. "It" being anything on their minds from the intricacies of family life to the whispers after love-making or, upon going to any party, asking if she is too fat or to too skinny or just right or, afterwards, if she said too much or not enough or why he just won't tell her what he is thinking.

Women want to talk.

I often wonder what men want.

Of course, I realize you can't generalize or stereotype gender or take anything for granted from anyone. But I do wonder. And it is a relief that the "what it means to be a man" is so much more open as is the notion of "what it means to be a woman," or if one identifies as queer, than how customs and mores were ascribed to our parents and grandparents and previous generations.

The beauty of gender fluidity in the 21st century and the

freedom that LGBTQ communities have brought into a global collective consciousness is freeing. To be queer is to be oneself and not stuck in any binary of *he* or *she*, *him* or *her* but rather *they, them,* and *theirs.* Pronouns are receptors to identity, a matter of respect, not simply modifiers of nouns—a person, place, or thing—but part of an evolving language, a broadening and deepening of the discourse between human beings.

What a relief.

I remember when I first met Louis Gakumba, who would become our son, in Rwanda. He would walk with his friends and hold hands. This was the custom. To my eye, it was such a lovely expression between men. There was nothing self-conscious about it.

And when he came to America, one of the first places we went together as a family was to Yellowstone. I remember walking behind Brooke and Louis in the Norris Geyser Basin with steam rising all around us and an occasional geyser erupting. Though my delight was in sharing the thermal activity before us, it was heightened in watching these two men I loved holding hands as they walked the wooden boardwalk between the wonders of America's first national park in Montana. It all felt so tender.

Louis no longer holds Brooke's hand. He has assimilated himself into the norms of this country. Nor does he hold any man's hand in America because it signals something else, especially among the men in our family, firmly grounded in the mythos of the American West. Guns, boots, and brawn. This saddens me.

Linda Asher, my surrogate mother, sister, and friend is eighty-seven (the same age as my father). We hold each others'

hands when we walk the streets of New York, day or night in any season. It offers us both solace and pleasure. I have watched older women do this in Italy, France, and Spain, and all over the world. It touches me as I watch other women touch each other.

I want to keep this tradition alive among my own friendships with women and men and members of my own family. Especially now, in this era of the coronavirus, where we can touch no one save our closest intimates who we have sheltered in place with together.

The two young Pakistani men dressed in white tunics standing in front of a brick wall are holding hands. They remind me that touching matters, holding hands matters, connecting without words, something akin to electricity moves lovingly between us.

Always,
Terry

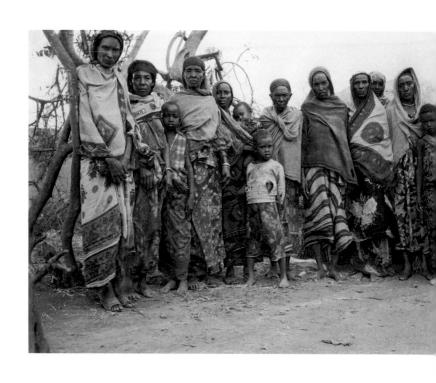

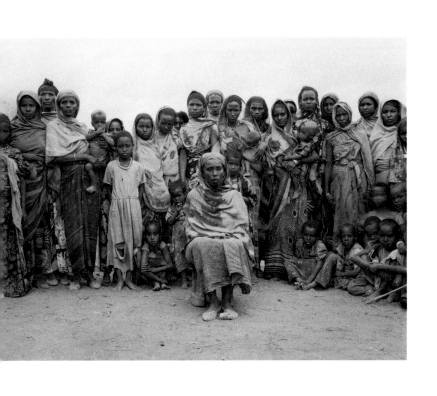

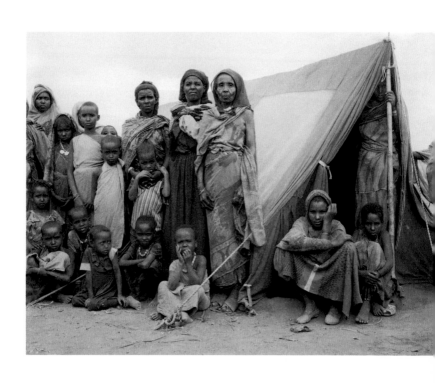

Dearest Fazal,

Marabou stork flying above Gabbra tribal matriarch with women and children, Ethiopian Refugee Camp, Walda, Kenya, 1993

Sometimes, my friend, your captions reach me as poems. This is one of them. Imagine a stork, this large gangly prehistoric-speaking bird, rendered as the tiniest of dots above the matriarch who sits front and center in the body of the triptych. Had it not been for you mentioning the marabou stork, I never would have seen the "Mother-Bird" that brings forth babies. Sixty-four women and children appear in the wings of the triptych on either side of the center panel, beautiful manifestations of Gabbra lineage and legacy.

Imagine.

I can't help but recall these words: "Once upon a time, when women were birds, there was the simple understanding that to sing at dawn and to sing at dusk was to heal the world through joy. The birds still remember what we have forgotten, that the world is meant to be celebrated."

What does celebrated mean in the faces of women in a refugee camp?

What does celebrated mean within the ranks of the poor?

What does celebrated mean in times of famine and thirst?

To be celebrated means to be acknowledged and honored. This gathering of women and children tied to the matrilineal cord of the Gabbra is both an acknowledgement and honoring

that they live, they belong, and they will continue. You made a picture, and in so doing, the Gabbra matriarch and her progeny are celebrated, remembered, not forgotten—seen.

One of the things Rwandan women, Kenyan women, and Ethiopian women have shown me is how to celebrate in the midst of the struggles. To dance, to sing, to hear the ululations of women when someone has died or when a mother and her newborn return home is a moment celebrated in the cycle of life. In these moments when feet meet the earth and the voices of women touch stars the universe is realigned through the lament and laughter of women—even as they mourn, even as they grieve, even as the strength of their character carries the community forward.

This full range of experience born out of their bodies does not lie. You see it in their eyes, their faces, how some faces tilt to the side, some stare straight ahead, other faces are hidden, but what is never hidden is the nobility of survival. You can see the power of their arms folded or hands clasped, or arms and hands brought down to their sides; the way they hold their babies on their hips or wrapped around them, front and back. You see the toll and toil of their lives, alongside their dignity earned that is theirs alone.

Even though this photograph is black and white, Fazal, the vibrancy of colors amid the bold patterns and forms reflected in each woman's chosen kitanga registers as a rainbow spanning across these panels. Each woven shawl is an embrace of necessity and beauty.

From afar, I cannot distinguish birdsong from women's songs rising from the generations like heat waves shimmering in the desert.

What does celebrated mean in a global pandemic?

I think of the widows and mothers and daughters and sisters and lovers mourning their dead, their beloveds, taken during this planetary plight of sickness. Perhaps what we need to properly acknowledge and honor the 665,581 individuals who have died from Covid-19 is a unified ululation of women wailing and howling together, a collective keening that will travel on the winds and be heard around the world.

Love,
Terry

Dearest Fazal,

In my hands, I hold the portrait of a woman laborer in South Africa. She is sitting on a bed with her arms outstretched, both hands gripping the blanket that covers the mattress. The woman wears a white knitted cap pulled over her ears and hair. She is dressed in a short-sleeved white blouse that is well-pressed and loose trousers. A light-colored apron with shoulder straps protects her clothes. It is torn at the hem that covers her knees. Her ankles appear to be crossed, though her feet are not visible, outside of the frame of the camera.

The wall in the room she inhabits is bare, with the exception of two nailed pieces of paper and a horizontal wire bowed by three hangers, one empty and two supporting articles of clothing—a large vest and a dress unhemmed.

On the floor is an oil drum, a cardboard box, and something like a rolled mat. It is a lean setting that serves as a still life.

I don't mean simply to re-describe the photograph you have taken. I do mean to retell the visual story you have created. For in the retelling of any story, there is an opportunity to deepen and even prick the conscience of the community.

To labor. To exert one's body and mind. To labor. To work or toil for wages on behalf of an economic system. To labor. To deliver. To produce an object, a service, a child. To labor. To worry excessively over details. To labor. To be forgotten, exploited, and unseen.

One of the positive outcomes of the harrowing outbreak

of Covid-19 has been determining what is essential, including essential workers. These laborers in our society who we have taken for granted and have remained largely invisible include the frontline health care workers, grocery store clerks, warehouse and delivery workers, and pharmacists. Those of us who are working at home are discovering what it means and feels like to be non-essential except to our friends and families. Not long ago, I called a fellow writer and asked what she was up to. Ever wry, she said, "Just contemplating my irrelevancy."

I see the woman in this photograph as an essential laborer. Time is not to be contemplated but used to make a livable wage to support and feed her family. And in so doing she is keeping the economy moving forward, providing a service that helps others. It may not matter the kind of work that she does, but that she does her work with pride and skill. This is the ethic we were taught by my father. All three of my brothers were laborers with a shovel in hand digging the trenches where waterlines, gas lines, and sewage lines would be laid and covered creating the infrastructure that makes it possible to turn on a faucet, turn on your stove, and flush your toilet. My brothers were essential workers and largely unseen, until a gas line would leak, or your sewer backs up, or you have a break in your waterline.

The essential workers are also the vulnerable workers. My brother Hank almost died from the coronavirus in March. He traced it to another worker in the trench who had just been hired from working in a crew in California. When the State of California went into lockdown, he was laid off. He came to Utah. He carried the Covid virus with him. He became sick, left the crew that my brother was on, and was hospitalized. Three of the other men he was working with came down with

the virus shortly after he left. It was early on in the pandemic and so nobody really knew what was happening until, in my brother's case, the doctors realized this illness was something different. My brother survived as did the other crew members. But the worker from California disappeared. No one knew what became of him—whether he lived or died.

Not long ago, I was in Sioux Falls, South Dakota, home to the Smithfield Foods Pork Processing Plant, one of the largest clusters of Covid-19 cases in the United States. I was in Sioux Falls as a visiting writer at Augustana College. I had some free time in the afternoon and found my way down to the Big Sioux River. The physical beauty of Sioux Falls is juxtaposed with the stench from the meat processing plant, so vile, so foul, I had to wrap my scarf around my nose and mouth.

Sitting by the Falls, with the intent of looking for birds, I met two men from Iraq, one fishing for carp, the other telling me stories of the war; of his wife who can no longer speak or stay in one place for long because of the horrors she witnessed associated with Abu Ghraib; of his four children scattered as refugees: one in Dubai, one in Egypt, one in New Zealand, and his son in northern Iraq who refused to leave on principle. He showed me pictures of his six grandchildren. We both wept.

These two brothers, Fazal, one a doctor and the other an accountant, now recent immigrants in America, were both working at Smithfield Foods Pork Processing Plant. "Grim, disgusting, inhuman," were the words they used to describe the working conditions. But so were words like "grateful, temporary, and it won't always be like this…" They spoke of encountering the world within the factory, how most of the workers were from elsewhere, struggling to survive.

"Name a country at war," I remember one of the brother's saying. "And I'll name you someone I am working next to from that conflict zone."

We ended up taking a walk together. On one of the rocky outcroppings that appeared as an island in the midst of the Falls, I noticed two exposed eggs, large and cream-colored on the quartzite stones. I asked the brothers if they knew what kind of eggs they were. Not only did they know they were Canada Goose eggs, but they had watched the pair make a scrape in the sand between the rocks, a week or so ago, and kept coming back to check on the eggs on the days they made it to the river.

On April 15 of this year, I thought about those brothers who worked at the meat packing facility in Sioux Falls when it was reported in the news that there were 1168 cases in South Dakota, one of the hot spots in the United States for the coronavirus. Nine hundred and thirty-four of those cases were in Minnehaha County, the location of the Smithfield Foods plant, 644 people with connections to the plant were infected, including 518 employees.

I went back and reread Upton Sinclair's book, *The Jungle*.

...preventable diseases kill off half our population. And even if science were allowed to try, it could do little, because the majority of human beings are not yet human beings at all, but simply machines for the creating of wealth for others. They are penned up in filthy houses and left to rot and stew in misery, and the conditions of their life make them ill faster than all the doctors in the world could heal them; and so, of course, they remain as centers of contagion, poisoning the lives of all of us, and

making happiness impossible for even the most selfish. For this reason, I would seriously maintain that all the medical and surgical discoveries that science can make in the future will be of less importance than the application of the knowledge we already possess, when the disinherited of the earth have established their right to a human existence.

Amen.

Thank you, dear Fazal, for your soulful portrait of this day laborer. I feel as though I have been in conversation with her. I recognize her as I recognize my own brother as a laborer, a working man. And as he continues to remind me, it is never us versus them—even within our own families.

It makes me so happy that you and Hank met each other over Thanksgiving, and a shared extended stay in Castle Valley. We still laugh over your exuberant determination to transform simple cream into whipping cream that instead only created mayhem after the dogs lapped it up when we weren't looking and when we did look, we wished we hadn't.

What followed was a labor of love with laughter and dry heaves. Forgive me, I digress.

I saved this recent note Hank wrote to me after we had a contentious political discussion. He was in his work clothes, caked with mud after working a ten-hour day in a rainstorm followed by 100-degree heat in Salt Lake City:

"Terr, it's not left or right, us or them, it's we—talk about we. Please talk about we. Do you know how sad it is to be

cynical, to not believe in anything or anyone because whatever or whomever you believed or loved walks away or dies or is insane? Terr, it's so hard, it's so hard. I'm just glad I've got my dogs and a screech owl sings to me every night outside my bedroom window, sometimes I go out and shine a light on her and she still keeps singing in the dark."

What is essential, Fazal, is that even though we may think what we do doesn't matter, I believe it does. I believe art is also labor. Your photographs, my words, the stories we tell and retell through the art of living is how we sing in the dark. And why during this pandemic when we have all been brought home to isolate and quarantine and social distance with our masks on—it is the music we hear, the books we read, the paintings we recall that move us, the films we watch and the photographs we seek—these works of labor continue to keep us connected to what is real and true and terrifying and good, reminding us what it means to be human when the world goes dark.

The woman who stares at me now, I see her differently. The empty hanger above her head has become a halo—I do not mean to say I see her as an angel with wings, but as a guardian of labor, to deliver and bring forth something of yourself day after day after day.

With love,
Terry

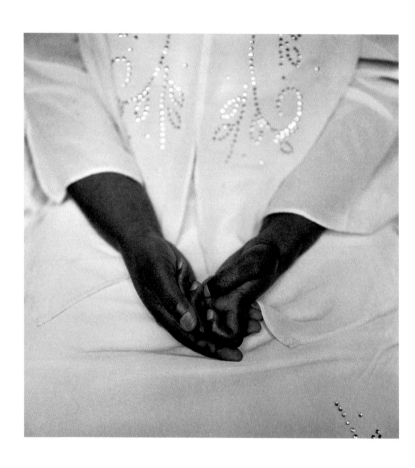

Dearest Fazal,

Good morning. A black-chinned hummingbird continues his sweet sipping of the fuchsia blossoms on the coyote willow. Mid-morning heat creates a pale light that I have come to love in July in contrast to the vibrant fire-flaming sunsets on the red rocks and mesas at dusk. I used to dread summers in the desert, now I savor them.

The forecast for the next seven days is scorching heat, days well over 100 degrees. The cheat grass is burnt. The red sand is cracked. And we just crossed the threshold of 150,000 citizens dead in America from Covid-19. The virus is surging in Florida, Georgia, Texas, Arizona, Idaho, Montana, and Utah. Deaths in Indian Country continue to escalate. A senior health care center in Blanding is being investigated for negligence with over fifty people testing positive, patients and staff alike, and three deaths in the last day or so, one of whom was Mr. Redhorse, a well-known medicine man among the Navajo, a relative of Ida Yellowman.

Last night, after a volatile cloud burst with thunder and lightning, a golden light fell upon the valley that was biblical, with a Black Rainbow arching over the valley. I didn't know there was such a thing. But there is—known as "Alexander's Band"—first noted by Alexander of Aphrodisias around 200 CE. It appears where water droplets reflect light away from the viewer. It was ominous and exquisite, at once.

When I lifted this photograph of Justine's hands folded

on her lap with dazzling drops of sequins reflecting light, the picture was upside down. Without my glasses, Fazal, I saw the Black Rainbow.

By your side,
Terry

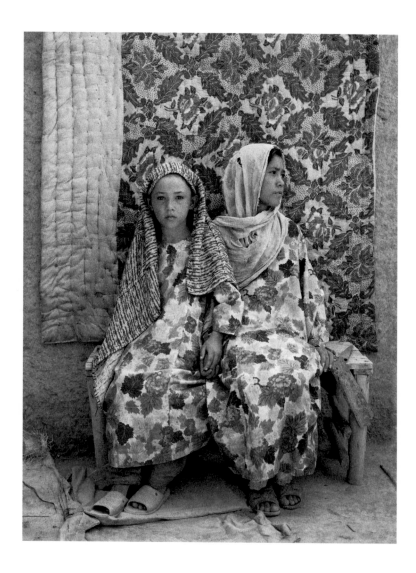

Dearest Fazal,

Tonight, a waxing gibbous moon is rising above Round Mountain as I write to you.

As kids growing up, we just called it the three-quarter moon. In five more days, we will be honoring the full moon. We call it the Sturgeon Moon according to the *Old Farmer's Almanac*.

At first, I thought what a strange naming of a moon after this particular fish, but then I was reminded that this is the longest living freshwater fish having evolved on this planet for some 419 million years. It has been considered by scientists to be "a living fossil" having moved through time almost without change. But recently, a group of scientists from the University of Michigan found the opposite to be true. The sturgeon's size has in fact evolved significantly over time, making it one of the fastest-evolving fish on Earth. What a perfect name for this August moon—to be blessed by a species that knows how to change, evolve, and grow. I will anticipate its presence.

The day you were born, the moon was a waning crescent. The day I was born it was a waning gibbous. If the moon can pull ocean tides forward and back, creating high tides and low, how might the moon affect our watery bodies?

"I am made and remade continually," writes Virginia Woolf in *The Waves*. "I am not one and simple, but complex and many."

The complexity of patterns, the beauty of sisters Sima and Shahima dressed in flowers, seated on a wooden bench with a quilt of silk behind them, designed with leaves and blossoms—it

all feels like a living garden. That you tell me in your delicate script on the back of the photograph that these girls are living in an Afghan refugee village in Nasir Bagh, the North West Frontier Province of Pakistan, undoes me. It undoes me because I associate a refugee village with displacement, but these girls convey something more.

What is it?

Moon. Water. Garden. Roots. Heaven and Earth. The power of patterns and cycles.

Full Moon. Crescent Moon. Gibbous Moon, waxing and waning. These sisters are draped in patterns of their own growth. The eldest is looking away, her headscarf torn. Her feet face the camera. The youngest is looking directly at you. Her headscarf resembles an animal skin with stripes, and is tucked behind her ears, then left to cascade over her small hidden shoulders. Her feet are facing right.

The center of gravity for me, Fazal, is located where the sisters are gently holding one another's hands in the crease where their bodies meet—their fingers touching loosely, lightly—Sima's fingers cradled in Shahima's hand. I am reminded of Frida Kahlo's painting, *Las dos Fridas*, where two Fridas sit side by side on a bench. They are also holding hands, with the Frida on the viewer's right cradling the hands of Frida on the left, similarly, as the two sisters. Both Fridas have their hearts exposed; what connects them is a shared vein. The left Frida has had her heart broken the right Frida holds a photograph of her beloved Diego Rivera.

How old does one have to be in order to have a broken heart?

If one's heart does break, adorn yourself with flowers, and find your twin with whom you can share your spilt blood and an inherited pattern of love and loss.

I have never had a sister, but this is how I imagine it would be: shared sorrows and joys; the older sister watchful, wistful; the younger sister curious and brave. I see asperity more than anger in Sima's eyes and the lines eroded by tears; and worry on Shahima's face. The hands of the girls' mother could have hand-stitched the quilt. Would one carry such an heirloom for comfort? Of course, this could be my projection. Brooke's mother was a hand quilter, she rarely used a sewing machine. In the room where you sleep when you stay with us in desert, her hand-stitched quilt hangs on the west wall. It, too, speaks of textures and patterns made with leaves and flowers and waves. She saw this particular quilt as a window with open shutters looking out on the cycle of seasons—a poem.

Again, Woolf: "And the poem, I think, is only your voice speaking."

What if we are merely poems made of patterns meant to be held in place, sometimes read silently, sometimes read out loud, memorized and cherished, to be called upon in times of pleasure and need. And yet each time we return to familiar lines on a face or a page, we find added meaning and depth as we meet the words anew from a place of unexpected growth as a result of the waxing and waning of where we have been.

A refugee camp. These beautiful sisters dressed in flowers, growing in place. Displaced. They are holding each other's hand in the crease where their bodies meet. One looks away. One looks ahead. They know things we do not. A pattern begins to emerge. *Repetition is spiritual.* A hand-sewn quilt of blossoms and leaves hangs behind them. Sima and Shahima are seated on a bench.

Divine specificity.

Today is the three-quarter moon. Waxing gibbous. In five more days, the moon will be full. Sturgeon Moon. To continue to evolve and grow. The day you were born, the moon was a waning crescent. The day I was born the moon was a waning gibbous. If the moon can pull the ocean tides forward and back, creating high tides and low, how might the moon affect our watery bodies?

Waxing and waning. Our bodies, a poem unspoken.

In place, displaced,
Terry

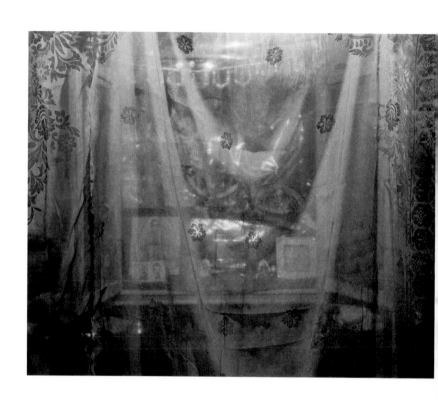

Dearest Fazal,

The veil between the dead and the living is thin and porous
and daily.

This is what I know.

Truly,
Terry

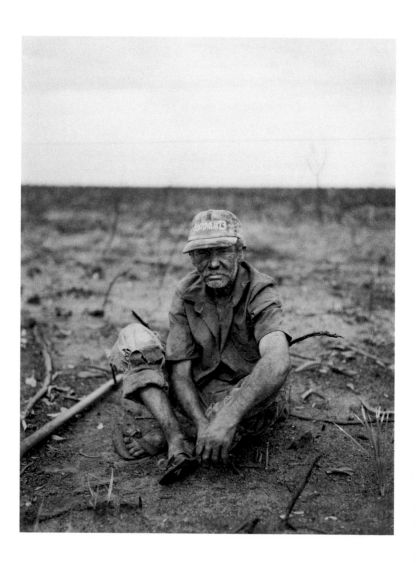

Dearest Fazal,

Well, little Issa is back home from the vet, and she is going to
be fine. After all the tests, her oxygen levels, her heart rate, the
blood work, the X-ray on her left paw, and then shaving her
arm to see if they could see any puncture sites—the verdict not
certain, but likely, is that she was bitten by a spider—a black
widow. The vet found toxins in her bloodstream. Her fever was
high, 105 degrees, and she went limp like a tiny rag doll. We
felt so helpless. All we could do was hold her close. She is recov-
ering with Basho by her side.

It's so hard when animals are hurting and they can't tell you
what's wrong. They are stoic in their pain. Whether it is a cat
or a mountain lion, a koala bear or a kangaroo, or the sloths
and capybaras in the Amazonian rainforest, they suffer. When
I think about the three billion animals that perished in the
Australian fires this year, it shatters my senses. How do we even
begin to fathom the scope and scale of the wildlife losses from
fires and drought and the destruction of habitat.

This is a time of deep suffering, not just for our species, but
all species.

I ponder this photograph, *Mauro Ferreira das Neves, migrant
laborer, burning and clearing the land on the farms around Grande Sertão
Veredas National Park, Brazil, 2001.* This is a tough one, Fazal.

You could not have known what was coming to the
Brazilian rainforest two decades later in the fires of 2019—that
906,000 hectares (the size of New Jersey) would burn and that

2.3 million animals would die. This on top of 72 million hectares lost to deforestation since 1970 in the Brazilian Amazon, the highest rate of deforestation on Earth.

Mauro Ferreira das Neves is not to blame, nor are other migrant laborers. Politicians like President Jair Bolsonaro are to blame. Just recently he said he has "mold growing in his lungs" after contracting Covid-19 virus. Like our president he minimized the danger of the pandemic.

Last year, on November 20, 2019, it was reported by a São Paulo newspaper: "Brazilian President Jair Bolsonaro shrugged off a government report that deforestation in the Amazon reached an 11-year high on his watch, saying Wednesday he expects the destruction of the world's largest tropical rainforest to continue. 'Deforestation and fires will never end,' the pro-development president told reporters in Brasilia. 'It's cultural.'"

In response, Marcio Astrini, public policy coordinator at Greenpeace Brazil, said, "About 90 per cent of the destruction of the forest occurs illegally, therefore, the only cultural aspect of deforestation in the Amazon is the culture of forest crime, which the government does not seem to want to confront."

Here are the facts: 9,166 square kilometers (3,539 square miles) were cleared in 2019, the highest number in at least five years, according to Brazil's National Institute for Space Research. In 2018, the deforested area was 4,946 square kilometers. The sharp increase overlapped the first year in office of President Jair Bolsonaro, a climate change skeptic who has eased restrictions on exploiting the Amazon's rich natural resources from wood to gold.

This is not so different from actions taken by Donald Trump who views protecting the environment as bad for

business. Over 100 environmental regulations have been reversed from Obama-era limits on planet-warming carbon emissions governing power plants and automobiles to a softening of regulations that ensured clean air and water including the monitoring of toxic chemicals to safeguarding the health of endangered species and migratory birds.

Fossil fuel development on public lands from our national forests to national parks and monuments like Bears Ears and the Arctic National Wildlife Refuge (as you well know) is viewed by this administration as a patriotic act of oil independence. While environmental laws such as the Endangered Species Act, the Clean Air Act and the Clean Water Act must be curtailed, relaxed and rewritten to protect the "American Way of Life."

And in the case of NEPA, the National Environmental Policy Act of 1969, this law requires federal agencies to understand the environmental impacts of their actions should a particular area be opened to logging or fracking or commercial development. It also invites the public to comment and be part of the decision-making process by providing alternatives to the prescribed actions. Two weeks ago, July 15 to be exact, the Trump administration gutted NEPA—a gift to corporations and polluters—while closing citizen participation to the American public.

As I mentioned to you the other day, we had Mary and O.B. over for drinks on the patio.

Mary O'Brien has spent thirty years working on NEPA and providing viable alternatives for grazing initiatives, rare and threatened plants, and the dangers of certain toxins. She was concise and precise in her reaction to NEPA being dismantled. "NEPA is democracy." Full stop. She looked at me and then

said, "We're fucked." Her alternative now: "We need to proceed as though NEPA is in place."

So when I look at this image of Mauro sitting on barren soil cleared for the farming of soy beans, I see a systemic breakdown of health—the health of our democracies, the health of our communities and sustainable economies, and the health of the planet. His gestalt speaks for the state of the crisis we are in—hunkered down in his fatigue with resignation etched on his face, weathered and worn from working in the elements. His body is bent and compacted below the horizon, a horizon that normally would be hidden by the immense canopy of trees, now gone—a flat line like death when a body no longer registers a pulse.

I feel a penetrating silence in this photograph like smoke where no birdsong is heard.

Where does one situate hope, Fazal? For me, it is what Mauro has placed to his side. Is it his shovel, or a hoe, or a rake? Let it be both symbol and tool. In the twenty years since you printed this picture, we have many tools through the sciences and public health that are helping us to understand globally that economic issues are social issues are issues of environmental justice that all have an impact on biodiversity. The intersectionality between racial inequality and the destruction of land in the midst of the ecological and climate crisis and now, this pandemic, are all interrelated and interconnected. Our health and the health of the planet are inextricably bound.

How to find the balance? How to find the will?

I was heartened to see that within Grande Sertão Veredas National Park there are strong international initiatives and local programs in place to support sustainable agriculture in

adjacent communities, alongside eco-tourism and environmental protection. A new consciousness is emerging that recognizes how a strong economy and a strong environment are complimentary not competitive. Collaborative ventures and unlikely partnerships are seeding new alliances that support one another, instead of the old ways that engaged combative warfare in the form of violence on the ground like the large-scale clear-cuts that paved the way for the timber wars of the 1990s in the Pacific Northwest. Earth First! tactics, acts of civil disobedience, and eco-warriors like Julia Butterfly who lived in a 180-foot tall, 1500-year-old California redwood for 738 days from December 10, 1997 to December 18, 1999 are emblematic of that moment. The same moment when the clearcutting of the Amazonian forests in Brazil was intensifying.

I wonder what acts of resistance we will see in the future.

We are in trouble, Fazal, and I keep thinking of John Lewis's phrase, "good trouble."

How do we make "good trouble" in the collaborations you and I have made vows to complete?

Although I have always seen your work as fine art, I have also known that, at its root, it is inherently political. You care. But I didn't realize how political and complex your portraits really are until spending this kind of time and reflection with each one of your "30 Moons" that you sent me as an homage to your thirty years as an artist devoting your focus and time to places of conflict.

With each photograph, Fazal, I see the trust you have created through the power of your relationships. I have witnessed first-hand how you engage with the people in each community where you choose to commit yourself—communities largely

comprised of people on the margins, people of color who have suffered the losses of land, livelihood, and the deaths of family members as a result of war, racism, and the physical consequences of environmental injustices like uranium mining and contaminated water. I have seen how you listen. I know how you have listened to me as I spoke of my own family's history of cancer from the nuclear tests in Nevada. You are my comfort and confidant. I have seen the toll it takes to do your work at the level of perfection you demand of yourself. The physical and emotional costs are real, though you rarely speak of them. When you were asked to travel to Ohio cold without knowing anyone to take portraits of those affected by the heinous actions of America's immigration policies it was not easy. But you found a way in through a shared empathy.

I have seen you take what is unacceptable, vile, and beyond inhuman and transform it into a formal representation of art that becomes a physical experience that soothes the heart, even as it breaks. You continue to show me beauty is a form of survival.

I see you, dear Fazal, as an empath. I see you as one who misses little from the smallest detail to the largest concept. I know you as a terrifying observer with a bright wicked humor. You often sign your letters "with love and laughter," and I find both whenever we are together.

You are among the most fierce and relentless defenders of justice I have known. And your stubbornness is a self-constructed wall. I never stand a chance of sway or influence when your mind is made up, even when it puts you at risk. Your direction is the arrow toward action. And yet and yet, I am also in awe of your vulnerability. Not only do you care,

you hurt, and even as you advocate and fight for those who are invisible to most, you are one step away from collapse.

Our bodies do not lie. Your back. My brain. They keep our physical and psychic balance in check.

Tonight, the moon-close-to-full is again shining above Round Mountain as I write to you. Saturn appears like a jewel overhead. Soon, Jupiter will be visible creating a triage between them.

I have taken to night-walking. Here in the outback of Castle Valley it is becoming increasingly surreal. Here in the timelessness of the desert, these sweltering days of heat rob all things alive of energy. It is a sustained entropy that cracks and shatters the surfaces of leaves and the carapaces of beetles, the scales of snakes. It steals color and song from birds. Only the spines of prickly pear have a heightened caliber of affect. The valley is blurred with smoke without origin and the air is heavy and stale.

Last night, I kept walking toward the moon, hoping to absorb her light, my mother's face illumined, but instead I was absorbed into the dreamlike trance of darkness that only inertia can inspire. The darkness within me was being met by the darkness outside of me—and yet as I kept walking I found I was surrounded by the eye shine of jackrabbits and deer and in the hidden secrecy of night walking I found a new form of communion.

In daylight, a black-tailed jackrabbit (the Diné call them "Grandfather") runs zig-zag between the chamisa and sage passing through the barbed-wire fence like a magician. Ravens gather in the morning light, flying west toward the rock formation Priest and Nuns, as mourning doves emerge

cooing from cracks and creases in the cliffs. Coyote stares, then moves on his way. And bluebirds appear as a matter of ceremony. This is what I miss in returning to Mauro Ferreira das Neves's landscape. It has been stripped of its stories, not only of the understory and overstory of the great Amazon rainforest and Cerrado, known as savannas, that blanket Grande Sertão Veredas National Park, but it has been stripped of its wildlife. They are gone, displaced, refugees left to die or find another home great distances away.

I fear, my dear Fazal, if I am honest and let down my protective shield riddled with bullet holes, that where Mauro sits at the site rendered dead by his own hands, that this may be our fate as well.

There are no more horizons to walk toward.

We are home.

Brooke and I send *abrazos* to you and Alex,
Terry

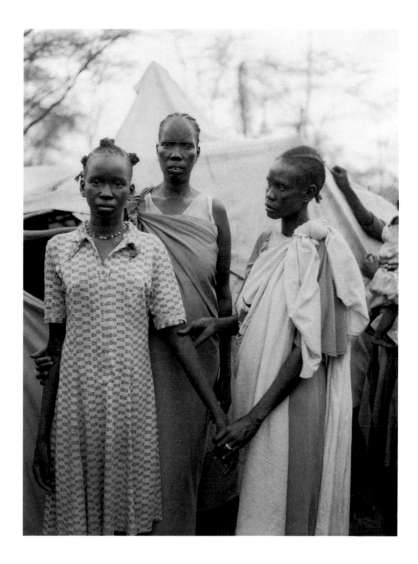

Dearest Fazal,

Hands.

Eight hands of women:

holding,

comforting,

supporting,

working,

tending.

One hand remains still by her side, resting, waiting—to cradle—two hands soon to come.

I will add two more hands, my own hands writing as these women's hands touch mine.

A woman's hands, palms facing Earth,
understands how water-witching works—sensing the unseen

bringing forth the flood, ending drought.

Arms around you,
Terry

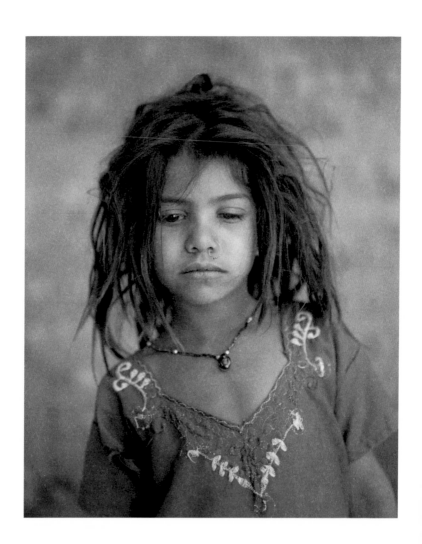

Dearest Fazal,

If I saw Muradi as your self-portrait, *Labhuben, child bride, out-skirts of Chandigarh, 2008,* would be mine. Not because, I, too, in your caustic words was a child bride in my teens, which you endlessly chide me about, but because I feel a kinship with her spirit—in wildness and fate—and see in her downward gaze an internal acceptance to find strength in a perpetual state of melancholia. This can be another form of resistance.

In Mormon culture, we are raised to marry young. We are raised to be obedient wives. We are raised to be mothers. I was married before I knew who I was, but I knew myself well enough that I was not obedient. Brooke and I knew together we would not have children. But later in our thirtieth year, we adopted a son from Rwanda. I became a mother at fifty. This was my choice. I chose to be married to Brooke. I chose to be a mother. And it remains so, after forty-five years of marriage.

When I read that, worldwide, twelve million girls are married before they are eighteen years of age, I am sickened. Forty-seven per cent of girls in India are taken as child brides before they are eighteen. Odds of furthering their education plummet, sexual abuse and sexually transmitted diseases are heightened, unwanted pregnancies are the norm, and the loss of self-confidence is its own epidemic, creating an uncertain future of economic dependence and poverty. A child bride made to serve her husband not only loses her childhood but

loses herself and her own sovereignty as a human being. This is another form of enslavement.

I see Labhuben's eyes about to look up and catch yours, mine, or someone in passing. She may know or not know the depth of her feelings of entrapment by what has been planned for her—the predetermined path of a child marriage to a man she does not know, let alone love, at a time not of her own choosing. This forced union is a crime and a sin. To be wed to a man decided by another because they see you as a burden, or because they can exact a price for your body, or because of the myriad reasons you are deemed unwanted and unworthy of being kept with no voice but the one being voiced on your behalf is a social evil.

But Labhuben is more than her captors can know. She is also a wild child, willful, and untamed with her hair of dreadlocks. One way or another, she will escape and for the rest of her life be led by the illumined path of the moon, full like tonight. She will not get lost in darkness because this is where she lives. Her night vision will only become clearer. She will get stronger, smarter, more agile. Her ability to look inward, as she is in this photograph, will become her power. Even though her gold nose ring is an homage to Parvati, the goddess of marriage, it also is a symbol of the beauty she will grow into. The necklace she wears is a talisman to protect her. Her embroidered shirt is her armor made by her mother, say it is red. Go, says the woman who was once where she is now. Go—and this wild child bride will hide herself in the Rock Garden on the outskirts of her city, where a particular artist reimagined a world where the outsider can exist until she finds her way home. The fact that in Chandigarh, India's first planned city designed by the Swiss-French architect

Le Corbusier, the outsider artist Nek Chand's recycled creatures, both human and wild, made out of the discarded and broken, can live side by side, in my unruly mind means the planned and the unplanned can coexist.

Fazal, we were on our way to the city of Chandigarh in December 2007 when you made this portrait. Would we have met? Would I have met Labhuben?

What is determined? What is chance? What is made? What is chosen?

Tonight is the thirtieth day of being with your thirty photographs. I am here in Utah. You are across the Atlantic in Zurich. Thirty moons later. These letters are for you.

I have had my grandmother's magnifying glass with its mother-of-pearl handle throughout this journey bringing me closer to where you have been and the people you met. It has allowed me to see your photographs with a more exacting eye. I see now that the necklace Labhuben wears could be her third eye focused on the place between her voice and her heart where truth is spoken and felt. If she was ten in this portrait, she would be twenty-three years old today. I wonder where she is.

We have the life we are given as children, and if we are lucky, the life we choose as adults. Call it a soul-following, conscious or unconscious, alive in our dreams. Perhaps, what makes us human is being in conversation with our soul which helps us navigate how we will proceed if we have the will and the desperation to listen.

I have chosen to proceed on foot, trusting the ground beneath my feet. My path is shown to me in moonlight. This is my ongoing cycle of discovery between darkness and light, the waxing and waning of our desires that change over time,

not so different from your black-and-white portraits that you make through a vision intuited but not seen until you watch the unfolding photographs before you develop.

Here is my unfolding vision that has emerged by paying attention to yours, day by day.

The Full Face of the Moon became my Mother's face on the night she died on January 16, 1987. That was the night I was born.

In truth, I am now 33 years old—this is my revelation today, Fazal—I spent thirty-two years with my mother when she was alive; and thirty-two years without my mother since her death. It is in this year of 2020 on this August Moon, through your gift of "30 Moons" that I have been made aware that I am now a sovereign. Just as I have been imagining freedom for Labhuben through her past self, she has given me the freedom of my future self—free here in the desert—at home.

Freedom, Fazal. What does that pathway look like for you now—side by side, present with your past and future self?

As artists, we have the freedom to create, disturb, and bear witness to the world we encounter. This is our privilege and our calling. You have been called to focus on people and place, often not their own place. Each of your portraits is an encounter. Your gift is in building relationships so that our humanity is illuminated even in darkness. And it is not without its pain.

Thank you for the invitation to look more closely at a world much larger than my own but intimate enough to see myself in the semblances of what it means to be human. I feel I have met powerful men and women and children by looking into their eyes, studying their gestures, being touched by the placement of their hands.

In collaboration, we can reimagine a different way of being in this world through our corresponding souls. This month contemplating 30 Moons in 30 days has broken me open, Fazal. Where we find ourselves now and how we make peace with our demons and dreams in this global pandemic and planetary pause is bringing us to our knees. Your portraits have become my daily prayer and practice.

Who knows what is coming in this country of ours we call America? Who knows how this world with temperatures rising will come together or split apart? I pray we might find the path of equity and justice for all. I pray that what feels like a reckoning and an awakening will bring forth revolutionary changes in consciousness desperately needed if we are to survive and flourish as a people where the health of the planet becomes our own.

The portrait of Labhuben is a child in pain. In her, I see all of us. What are we wedded to at our own peril?

Each of us are looking inward alone and outward together as the moon is beginning to rise in its fullness once again above the La Sal Mountains in Castle Valley, Utah.

My eyes look upward mindful that today is your father's birthday. You tell me Abdul Majied Sheikh would be eighty years old. I honor him this evening. I love the snapshot you sent me of him holding you on his crossed leg in front of the fireplace at home on 89th Street, between York and 1st Avenue. He is a handsome man, dark hair, strong profile like yours, wearing a well-pressed white shirt with his sleeves rolled up, his slacks have inched up past his ankle and he is barefoot. You are in a diaper. Your little hands are clenched. What moves me most is how you are staring at each other. Your gaze! Your eyes, always your focused attention on whomever you are with—clearly, a

gift you possessed from birth. He must be talking to you as his mouth is open as is yours. A father and son engaged. He would be so proud of you, Fazal, so moved by the dignity you have exposed in the faces of those you have met and know by name who are the displaced and discarded, even from the countries of where your father was born and his father's origins and his father's father's home ground from Kenya to Pakistan to India.

With the Full Moon as our witness, dear Fazal, my deepest bows to you, as we share these unexpected gifts from afar of 30 Moons met with 30 letters in this time of a global pandemic.

Across the distances, may these letters fly into your hands as wild birds.

Love,
Terry

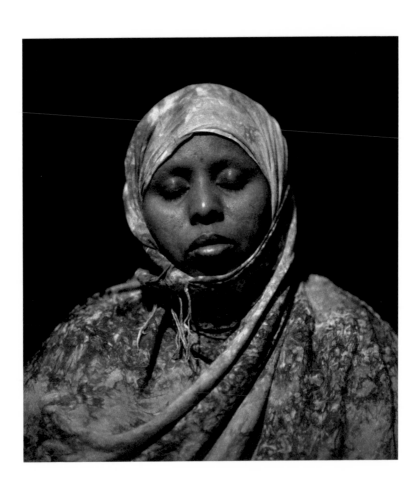

EPILOGUE

On the streets of Amsterdam, it is Ramadan. A woman closes
her eyes and says prayers. Everything she has lost, everything
she has given up, everything she still hopes for is a petition
before God. And in the stillness of the night, another woman
finds herself upside down and what once was sky becomes a
blurred body of water in love.

OPENING CITATION
p. 7: John Berger, *G* (London: Bloomsbury, 1996 [1972])

INTRODUCTION
p. 13. Virginia Woolf, *The Letters of Virginia Woolf: 1923-1928. Vol. 3*, ed. Nigel Nicolson and Joanne Trautmann (New York: Harcourt Brace Jovanovich, 1978), p. 574

9 JULY 2020
pp. 39–40. Terry Tempest Williams, *Refuge: An Unnatural History of Family and Place* (New York: Vintage, 1991)
p. 40. Edgar Allen Poe, *The Raven* (London: Signet Classics, 2009 [1845]), available at https://www.poetryfoundation.org/poems/48860/the-raven
p. 40. Rainer Maria Rilke, *Duino Elegies*, trans. C. F. MacIntyre (Berkeley, Los Angeles; London: University of California Press, 2001 [1923])
p. 41. Virginia Woolf, *Killing the Angel in the House: Seven Essays* (London: Penguin, 1995)

10 JULY 2020
p. 45. John Le Carré, *The Pigeon Tunnel: Stories From My Life* (London and New York: Viking, 2016). Reproduced with permission of Curtis Brown Group Ltd, London on behalf of John le Carré. Copyright © John le Carré 2016

12–13 JULY 2020
p. 54. Zadie Smith, *On Beauty* (London: Hamish Hamilton 2006), line taken from Nick Laird, "The Last Saturday in Ulster" in *To A Fault* (London: Faber, 2005)
pp. 56–57. *God knows, you need God to get through the/ Death of your son…* Alexandra Fuller, first published on Instagram, @alexandrafuller___

14 JULY 2020
p. 60. "Daniel Lewis Lee executed after Supreme Court clears the way for first federal execution in 17 years," CNN, July 14, 2020, transcript available at https://lite.cnn.com/en/article/h_f135e7af1b8b293d00ea987e9d435c5c
p. 61. Associated Press, "Dictator Said to Be Trailing in Malawi's First Open Election," *New York Times*, May 19, 1994

p. 62. D. L. Swerdlow, G. Malenga, G. Begkoyian, D. Nyangulu, M. Toole, R. J. Waldman, D. N. Puhr, R. V. Tauxe, "Epidemic cholera among refugees in Malawi, Africa: treatment and transmission," *Epidemiology & Infections*, vol. 118, no. 3 (June 1997), pp. 207–14

p. 63. Fazal Sheikh, *A Sense of Common Ground* (Zurich: Scalo, 1996)

17 JULY 2020

p. 75. "Red Light Revolution," *Newsweek,* February 14, 2019

18 JULY 2020

p. 80. Congressional Black Caucus, "The Congressional Black Caucus Mourns the Loss of Congressman John Lewis", July 17, 2020, https://cbc.house.gov/news/documentsingle.aspx?DocumentID=2211

p. 81. John Lewis with Michael D'Orso, *Walking With the Wind: A Memoir of the Movement* (New York: Simon and Schuster, 1998)

p. 82. Wangari Maathai, Obituary, *Daily Telegraph*, September 26, 2011

19 JULY 2020

pp. 88–89. Johnny Clegg and Savuka, "Dela," written by Johnny Clegg © 1989 Rhythm Safari Pty Ltd., from the album *Cruel, Crazy, Beautiful World*, Capitol, 1989

pp. 90–91. William Blake, "The Tyger" (1974) in *Songs of Innocence and Experience* (New Jersey: Princeton University Press, 1994), available at https://www.poetryfoundation.org/poems/43687/the-tyger

20 JULY 2020

p. 95. Henry Fountain, "In Parched Southwest, Warm Spring Renews Threat of 'Megadrought,'" *New York Times*, July 8, 2020

21 JULY 2020

p. 101. "Executive Order on Protecting American Monuments, Memorials, and Statues and Combating Recent Criminal Violence," June 26, 2020

p. 101. "Presidential Proclamation Modifying the Bears Ears National Monument," December 4, 2017

p. 102. Marc Wing, "It was like being preyed upon: Portland protesters say federal officers in unmarked vans are detaining them," *Washington Post*, July 18, 2020

23 JULY 2020

p. 113. Octavia E. Butler, *Parable of the Sower* (London: Headline Publishing, 2019 [1993]). Copyright © 1993 by Octavia E. Butler. Reprinted by permission of Writers House LLC acting as agent for the Estate

24 JULY 2020

p. 118. Emma Lazarus, "The New Colossus" in *Emma Lazarus: Selected Poems* and *Other Writings*, ed. Gregory Eiselein (Ontario: Broadview Press, 2002), available at https://www.poetryfoundation.org/poems/46550/the-new-colossus

p. 119. "Here in Minnesota we don't just welcome refugees and immigrants, we send them to Washington." Democrat Ilhan Omar, in her acceptance speech, after being elected to Congress, November 6, 2018. See Michelle Bruch, "Ilhan Omar's road to Washington," *southwestjournal*, November 12, 2018

25 JULY 2020

pp. 125–26. Nick Laird, *Glover's Mistake* (London: Fourth Estate, 2009)

26 JULY 2020

pp. 129–30. Terry Tempest Williams, *The Book of Men: Eighty Writers on How to be a Man,* ed. Colum McCann (New York: Picador, 2013)

27 JULY 2020

p. 137. Terry Tempest Williams, *When Women Were Birds* (New York: Picador, 2012)

28 JULY 2020

pp. 144–45. Upton Sinclair, *The Jungle* (London: Penguin Classics, 2002 [1906])

30 JULY 2020

pp. 153, 155. Virginia Woolf, *The Waves* (London: Vintage Classics, 2016 [1931])

p. 155. See Kiki Smith, "[P]rints mimic what we are as humans: we are all the same and yet everyone is different. I think there's a spiritual power in repetition, a devotional quality, like saying rosaries." in "Making Metaphors of Art and Bodies," Michael Kimmelman, the *New York Times*, November 15, 1996

1 AUGUST 2020

p. 162. "Bolsonaro says Deforestation will never end in Brazil," *Fohla de S. Paolo*, November 21, 2019

p. 14. Neesha Sharma's daughter, Kumkum, Aashray Adhikar Abhiyan (AAA) homeless shelter, Delhi, India, 2008

p. 18. Ramón Ramírez Rodríguez with his Saint Lazarus statue, Saint Lazarus Church, El Rincón, Cuba, 2002

p. 22. Nyirabahire Esteri, traditional midwife, holding newborns Nsabimana ("I beg something from God") and Mukanzabonimpa ("God will grant me, but I don't know when"), flanked by mothers Kanyange, Mukabatazi, and her mother, Rwandan refugee camp, Lumasi, Tanzania, 1994

p. 30. Rohullah, Afghan elder and former Mujahidin in the war against the Soviets, Afghan refugee village, Badabare, North West Frontier Province, Pakistan, 1997

p. 34. Shahria, Afghan refugee village, Urghuch, North Pakistan, 1998

p. 38. Night-walking in Benares, India, 2012

p. 44. Rooftop pigeon roost, Delhi, India, 2005

p. 48. Bhajan Ashram at dawn, Vrindavan, India, 2005

p. 52. Alima Hassan Abdullai and her brother Mahmoud, Médecines sans Frontières feeding center, Somali refugee camp, Mandera, Kenya, 1993

p. 55. Wezemana ("God is great") with her brother Mitonze, Rwandan refugee camp, Lumasi, Tanzania, 1994

p. 58. Kulaso Whisky's wives, Sarah January, Maria Vinti, and Shika Francisco, Mozambican refugee camp, Nyamithuthu, Malawi, 1994

p. 66. Cremation grounds, Manikarnika Ghat, Benares, India, 2012

p. 68. Unaccompanied Minors, Sudanese refugee camp, Lokichoggio, Kenya, 1992

p. 74. Rani, School for children of sex workers, Delhi, India, 2008

p. 78. Saladho Hassan Ali, on the day her daughter, Markaba, fought off an attacker while collecting firewood, Somali refugee camp, Hagadera, Kenya, 2000

p. 86. Kulprasadh Subba's funeral pyre, Bhutanese refugee village, Goldap, Nepal, 1996

p. 94. Chandra Bhaga ("Half moon"), widows' ashram, Vrindavan, India, 2005

p. 98. Israeli, born 1955, 2013. p. 99. Palestinian, born 1955, 2013 (diptych)

p. 108. The courtyard of Zubir's home, Pate, Kenya, 1989

p. 112. Muradi, born in exile, Afghan refugee village, Nasir Bagh, North West Frontier Province, Pakistan, 1996

p. 116. Carina, Deferred Action for Childhood Arrivals (DACA) student, following Sunday Mass, Sacred Heart Chapel, Ohio, 2019

p. 121. Rusi and Masoka, US immigrants from the Democratic Republic of the Congo; Carina, DACA student from Mexico, Cleveland, Ohio, 2019

p. 122. Catherine and Grace, US immigrants from the Democratic Republic of the Congo; statue of the Christ Child, St. Vitus Church, Cleveland, Ohio, 2019

p. 124. Pedro (name changed to protect privacy and due to the threat of refoulement), US immigrant from Latin America, Cleveland, Ohio, 2019

p. 128. Doctor Jan's son and friend, Afghan refugee village, Nasir Bagh, North West Frontier Province, Pakistan, 1996

p. 134–36. Marabou stork flying above Gabbra tribal matriarch with women and children, Ethiopian refugee camp, Walda, Kenya, 1993 (triptych)

p. 140. Day laborer, Lebowa homeland, South Africa, 1989

p. 148. Justine, genocide survivor, Democratic Republic of the Congo, arrived in the United States on May 9, 2019, Cleveland, Ohio, 2019

p. 152. Sisters Sima and Shahima, Afghan refugee village, Nasir Bagh, North West Frontier Province, Pakistan, 1996

p. 158. Krishna icons and images of the guru at rest, widows' ashram, Vrindavan, India, 2005

p. 160. Mauro Ferreira das Neves, migrant laborer, burning and clearing the land on farms around Grande Sertão Veredas National Park, Brazil, 2001

p. 170. Akuot Nyibol (pregnant at center) with her daughter Athok Duom, who is recovering from malaria, and her sister Riak Warabek, Sudanese refugee camp, Lokichoggio, Kenya, 1992

p. 172. Labhuben, child bride, outskirts of Chandigarh, India, 2008

p. 180. Seynab Azir Wardeere, Asylum Seekers' Center, Osdorp, the Netherlands, 2000

p. 183. Ramadan night, streets of Amsterdam, the Netherlands, 2000

FAZAL SHEIKH is an artist and author of fifteen monographs including *A Sense of Common Ground*, *The Victor Weeps*, *Moksha*, *Ladli*, *Portraits* and, most recently, *The Erasure Trilogy*. His work has been widely exhibited internationally at venues including Tate Modern, London; the Metropolitan Museum of Art and United Nations, New York; and the MAPFRE Foundation, Madrid. He is a fellow of the MacArthur, Guggenheim, and Fulbright Foundations, and Artist-in-Residence at the High Meadows Environmental Institute, Princeton University.

TERRY TEMPEST WILLIAMS is an American writer, educator, conservationist, and activist. Her many books include *Refuge: An Unnatural History of Family and Place*, *Finding Beauty in a Broken World*, *When Women Were Birds*, *The Hour of Land*, and, most recently, *Erosion: Essays of Undoing*. Her work has appeared in the *New Yorker*, the *New York Times*, and many anthologies as a crucial voice for ecological consciousness and social change. She is a fellow of the Guggenheim Foundation, a member of the American Academy of Arts and Letters, and Writer-in-Residence at the Harvard Divinity School.

Generous support for this project has
been provided by Jane P. Watkins

First edition published in 2021

© 2021 Fazal Sheikh for the images and introduction
© 2021 Terry Tempest Williams for the texts
© 2021 Steidl Publishers for this edition

All rights reserved. No part of this publication may
be reproduced or transmitted in any form or by any
means, electronic or mechanical, including photocopy,
recording or any other storage and retrieval system,
without prior permission in writing from the publisher.

Book design: Fazal Sheikh and Duncan Whyte
Text editor: Liz Jobey
Proofreading: Shela Sheikh
Separations: Reiner Motz, Steidl image department
Production and printing: Steidl, Göttingen

Steidl
Düstere Str. 4, 37073 Göttingen, Germany
Phone +49 551 49 60 60
mail@steidl.de
steidl.de

ISBN 978-3-95829-880-4
Printed in Germany by Steidl